BURT FRANKLIN: RESEARCH & SOURCE WORKS SERIES 763
Art History and Art Reference Series 31

DRAWINGS

BY

FREDERIC REMINGTON

DRAWINGS

BY

FREDERIC REMINGTON

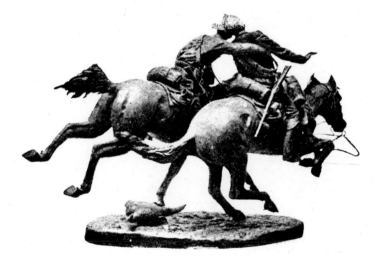

BURT FRANKLIN
235 EAST 44th STREET
New York, N. Y. 10017

Published by LENOX HILL Pub. & Dist. Co. (Burt Franklin)
235 East 44th St., New York, N.Y. 10017
Originally Published: 1897
Reprinted: 1971
Printed in the U.S.A.

S.B.N.: 8337-29357
Library of Congress Card Catalog No.: 77-101991
Burt Franklin: Research and Source Works Series 763
Art History and Art Reference Series 31

Concerning the Contents

SOME time ago I was spending a driven but happy forenoon among those shops where guns, and fishing tackle, and tents, and all the various necessities of a Western holiday are found. My time was crowded, and against the column of items on my list only a few checks had been made, when I reached "Groceries." Now, unless you have spent such forenoons and holidays yourself, the visit among the guns and fishing tackle may seem to raise questions of greater moment than any which could occur in the grocery shop. But this is not so. A man soon learns what weapons he prefers, and enters with his mind settled in advance; whereas, when it comes to evaporated vegetables, condensed soups, and pellets that can expand into a meal, you pause over each novelty, and with divided purpose wretchedly choose and unchoose until you are scarce more manlike than a woman. At least, such is my case; and having no minutes to squander this forenoon, I had pencilled my supplies to avoid discussion and temptation. Even while I was directing how I wished the parcels tied, mentioning that they were to be much jolted on the backs of horses, the shopman looked suddenly alert, and said this sounded like a camping trip. Yes, I told him in my elation, I was bound for the head waters of Wind River in Wyoming. Instantly the merchant fell from him; every trace of groceries left his expression; his eye beamed with eagerness, and he asked in the voice of one who gives the countersign, "Have you ever been to Arizona?" and hearing that I had, "I served there under Crook!" he exclaimed. Then names of the North and the South came to his lips—San Carlos, San Simon, the Gila, the Chiricahuas, the Tonto Basin, the forks of the Owyhee, Boisé, Bidwell, Harney—he spoke of many familiar to me; and next we were hard at it, this old soldier and myself, exchanging enthusiasms, gossiping in comradeship among the dried prunes. Thus I wasted minutes that I could not spare, yet lost nothing by it; my parcels were put up right. And when this errand was finished, he watched me depart from the shop door, and sighed, "I should like to see it all again!"

Since that day I have gone back to him, not always to buy groceries, but just to pass the word, and thus in the midst of city streets to conjure up Arizona, or Idaho, or Wyoming. My journeys through those regions have come after his time. I know none of his dangers and not many of his hardships. But I too have seen Summer and Winter in the Rocky Mountains, and the sun rise; and have slept and marched on trails where he went once. Between us is established a freemasonry: both of us have been *out there*; both of us understand. It matters not that one was an enlisted man campaigning against Indians, while the other is nothing but a voluntary pilgrim to the wilderness. Upon both alike has the wilderness set its spell. Yes; we certainly understand.

And what is this spell? Scarcely danger, for I have met no dangers worthy of the name. Scarcely freedom, since the enlisted man can do by no means what he pleases. Scarcely the immortal lift and purity of that great air, which I feel, indeed, but to which I can not remember hearing any trooper allude. Neither will the splendor of Nature explain it; the inspiring vastness, the transfigurations of the sunset, the swimming oceans of color, rich, subtle, endless, the more inexhaustible as the more observed. Only the pilgrims value these things. The chance for riches it certainly is not, nor the chance for crime. Crime and Fortune are there as everywhere; but the lost pocket-book is returned when it would not be in a city, and you meet with few that are troubling about dollars. Bloody and sudden as death often is there, it is not the planned murder so much as the quick blow of personal vengeance, the primitive man dealing with his fellow as in justice he expects his fellow will deal with him. Finally, it is not adventure alone. Though roving spirits have come to their own upon the plains, and with Indians and cattle-driving have let loose the fervid energy no town gave room for, dreamers strayed there too, many dreamers, and found happiness. In all of this I am speaking of the wilderness as it was once, and almost is no more. But you will find the dreamers still, now and then, riding alone from horizon to horizon, paddling upon sequestered rivers, hermiting in quiet cabins, all of them escaped from social codes, reaping the reward and paying the penalty in that archaic silence. For indeed the silence of that world seems to have come unbroken from behind Genesis, to have been earlier than the beginning, to make one with the planets, to have known mysteries, that dwindle Rome to a show. The little sounds of earth do not break it. In it the painted Indian walks naked, the twin of its mystery. In it you can wake or sleep, and no man hinders. Whatever law there is, rises from the ground or falls from the stars. For the very living, life seems to mingle with the origin before the dust has returned to dust. That is the spell for trooper or for pilgrim. From empire to empire, our wise brains have devised conventions that we may live together, but our unwise hearts crave the something that wisdom has renounced for us. So most of those you will meet in the wilderness, be they doers or dreamers, have followed the heart's desire and escaped back to Nature.

Ah, there is a lotus also in the West! It has drugged many that have never returned. But if you wisely tear yourself from it and re-enter the fold of

civilization, and in respectable content sell groceries, for instance, your heart will remind you of *out there*, now and then, a word like Owyhee or Wind River will give you a homesickness for the nameless magic of the plains.

Those happy ones who have known it meet always in that freemasonry which set the soldier and me talking like old acquaintances. And therefore I am going to show him these drawings; for every one will speak to him of *out there*. He will rejoice in their truth—indeed truth is a pale word—it is the vibrating thing itself which seems to rise out of these pages. Even to me they flash and throb with life I have lived, and how much more to a man whose years preceded mine and who had dangers where I had none!

I have stood before many paintings of the West. Paintings of mountains, paintings of buffalo, paintings of Indians—the whole mystic and heroic pageant of our American soil; the only greatly romantic thing our generation has known, the last greatly romantic thing our Continent holds; indeed the poetic episode most deeply native that we possess. Long before my eyes looked upon its beautiful domain, I studied the paintings; but when Remington came with only a pencil, I forgot the rest! And now I have seen for myself, and know how he has caught alive not only the roped calf, or the troop cook sucking his comfortable corn-cob, the day-by-day facts of the wilderness, but the eternal note also, the pity and the awe of that epic life. He has made them visible by his art, and set them down as a national treasure. Look at the Pony War Dance. That wild fury of religion, that splendor of savagery clashes down to us from the Stone Age. If you will open the Old Testament where Joshua delayed the course of the sun, or they blew down a city wall with a trumpet, you will come upon the same spirit. Look at the Medicine-men and the lightning. Again man's untamed original soul communes with a God of vengeance and terror. Is it not like Elijah and the fire-stroke from heaven upon the altar? Then turn to the Sheep-herder's breakfast. Unless you have known that solitude, no words of mine can tell you how Remington has been a poet here. With some lines and smears on paper he has expressed that lotus mystery of the wilderness. He has taken a ragged vagrant with a frying-pan and connected him with the eternal. The dog, the pack-saddle, the ass, the dim sheep in the plain, those tender outlines of bluffs and ridges—it is Homer or the Old Testament again; time and the present world have no part here!

Perhaps you do not value all this as I do. Perhaps the seamy side shuts you from the rest, and you shrink from the brutality of man and the suffering of beast. I have heard people speak thus sometimes, and give thanks for their books, and their bathrooms, for the opera, and for Europe where they can travel in a landscape seasoned by history. Well, Europe is richer, much richer, than any desert, and it is toward its use and comprehension, on the whole, that our struggling faces are set. Our fond, quack-ridden Republic looks, after all, toward the old world for its teaching. But we have a landscape seasoned by mystery, where chiefs and heroes move, fit subjects for the poet. If you do not see this, perhaps you are too near. Let me ask you to think of the bloody slaughters in Homer, and of all the great art you know from him to the present day; has not the terrible its share of notice? Doubtless you would have stopped Homer's reciting to you how bodies were hacked to pieces beneath the walls of Troy, and how swinish were sometimes the companions of Ulysses. But now you read it all with pleasure. Do you believe Art would have amounted to much if it had excluded pain and ugliness and narrowed its gaze upon the beautiful alone?

At any rate I am glad that we have Remington, one of the kind that makes us aware of things we could not have seen for ourselves. We have been scarce enough in native material for Art to let go what the soil provides us. We have often failed to value what the intelligent foreigner seizes upon at once. And I think as the Frontier recedes into tradition, fewer of us will shrink from its details. If Remington did nothing further, already has he achieved: he has made a page of American history his own.

Owen Wister.

DRAWINGS

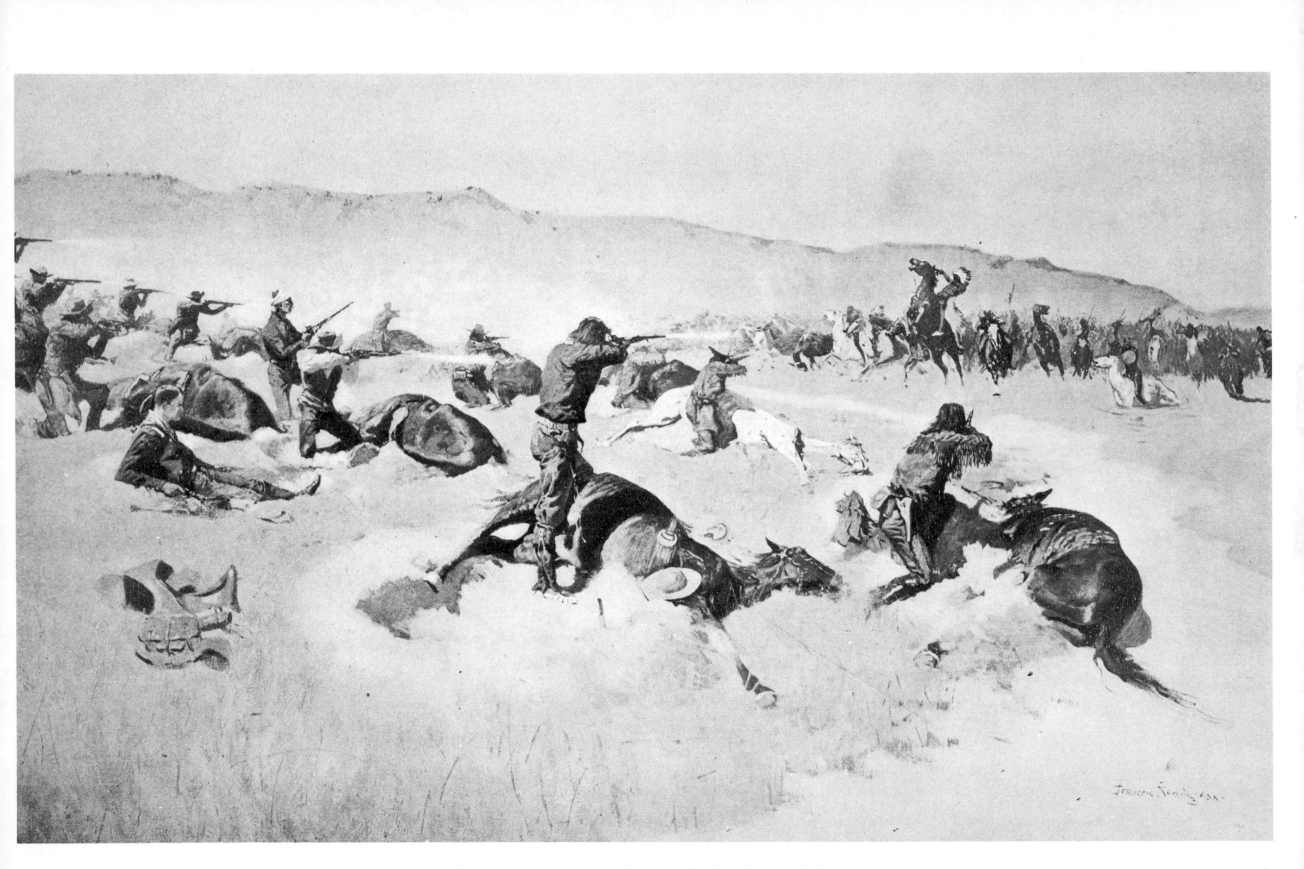

Forsythe's Fight on the Republican River, 1868—The Charge of Roman Nose.

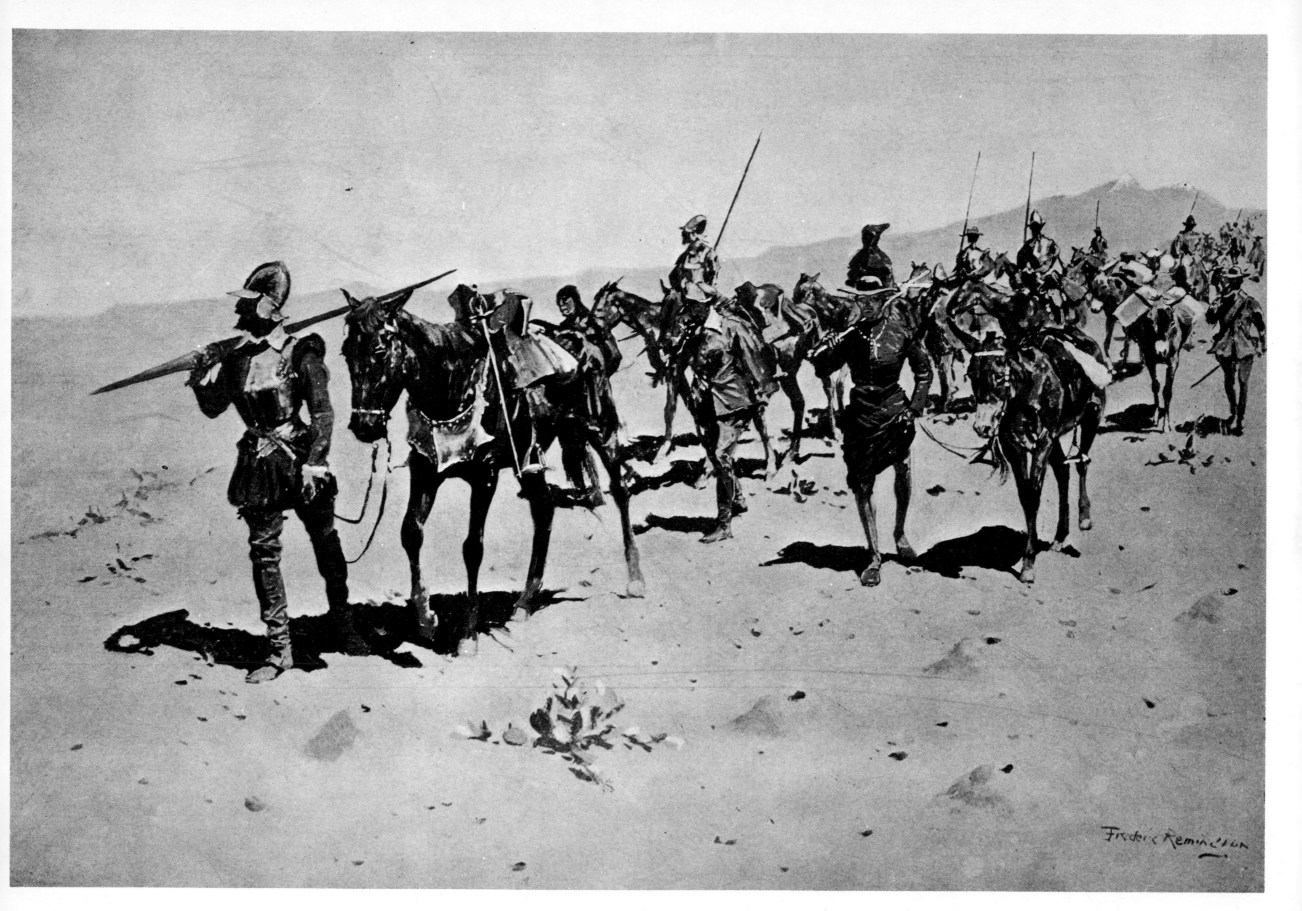

Coronado's March—Colorado.

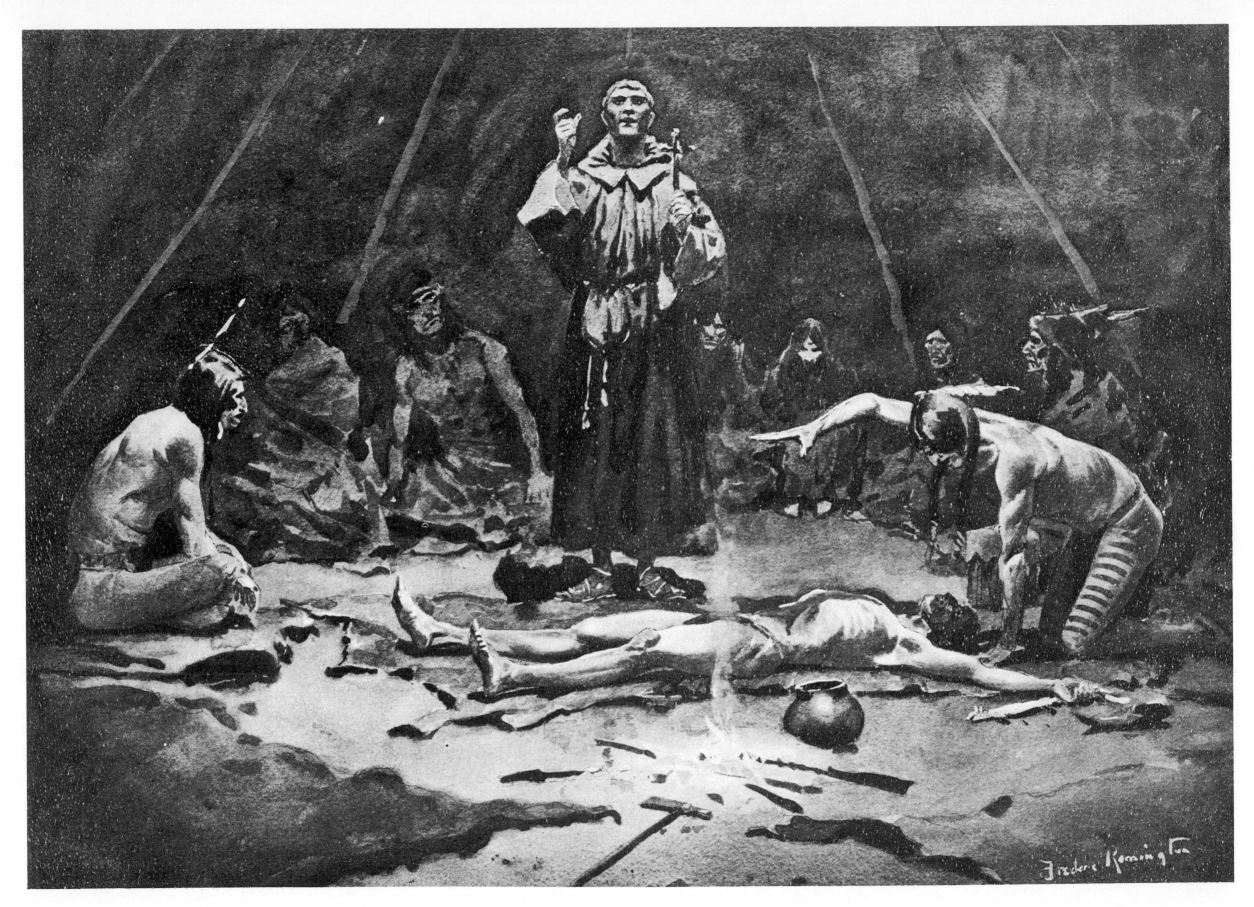

The Missionary and the Medicine Man.

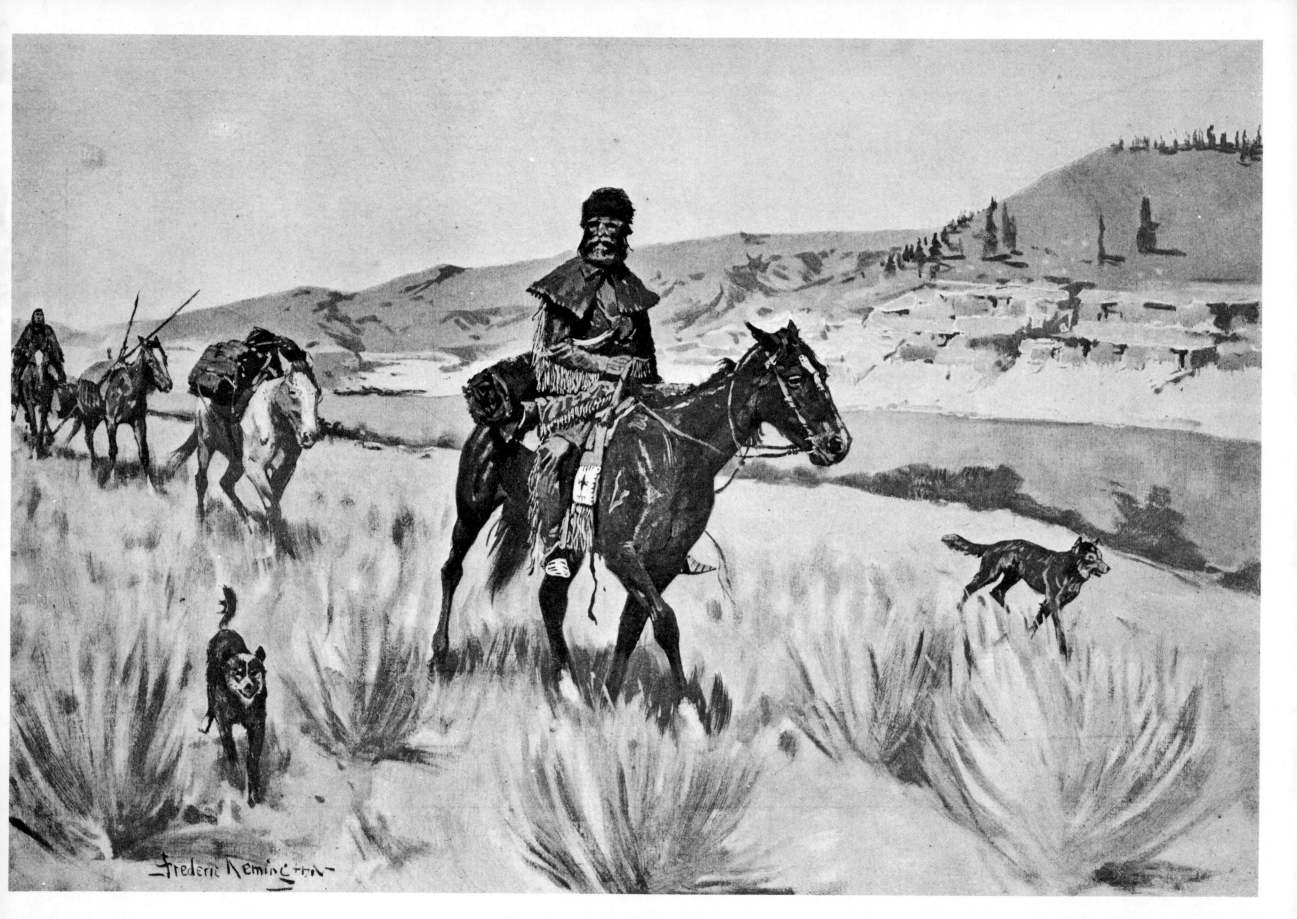

Hunting a Beaver Stream—1840.

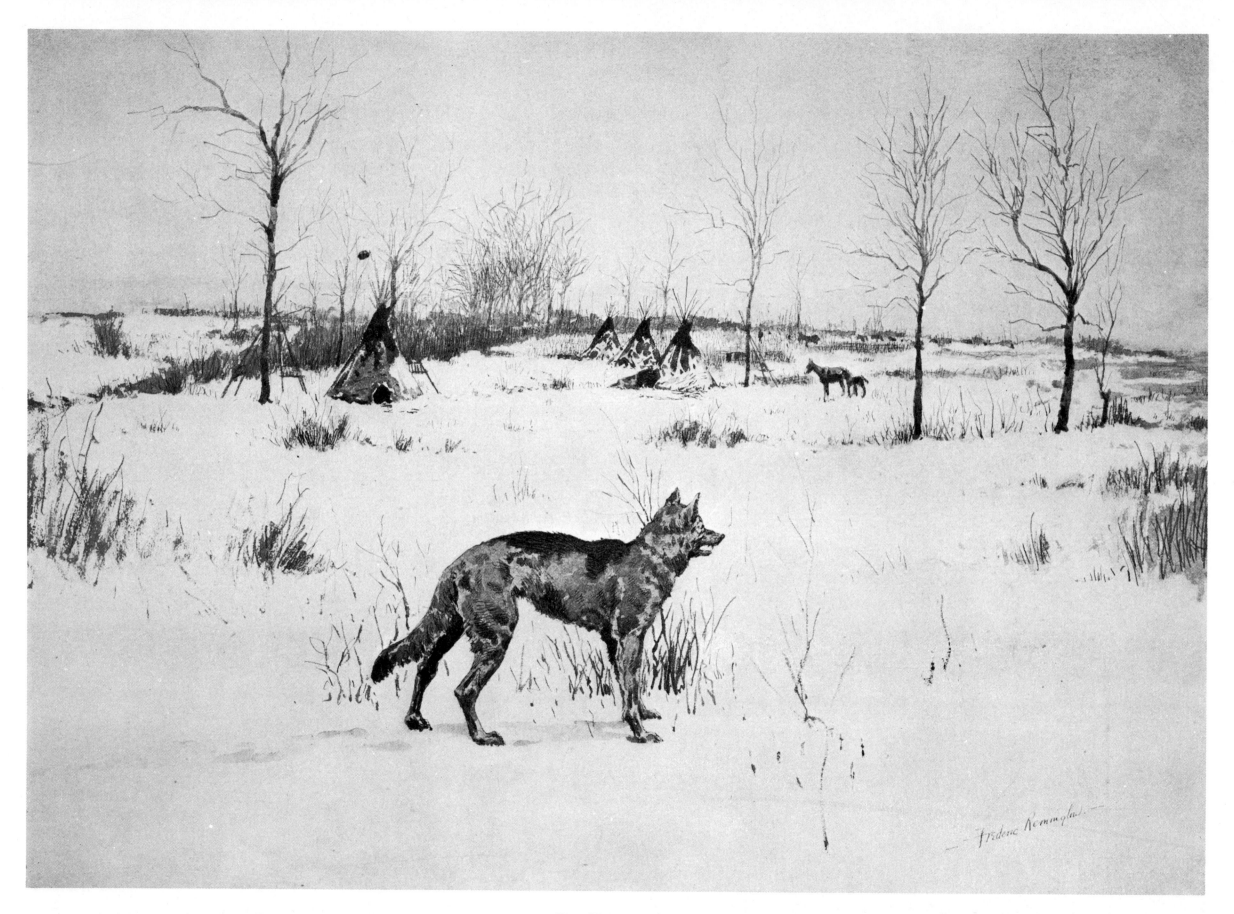

The Hungry Winter.

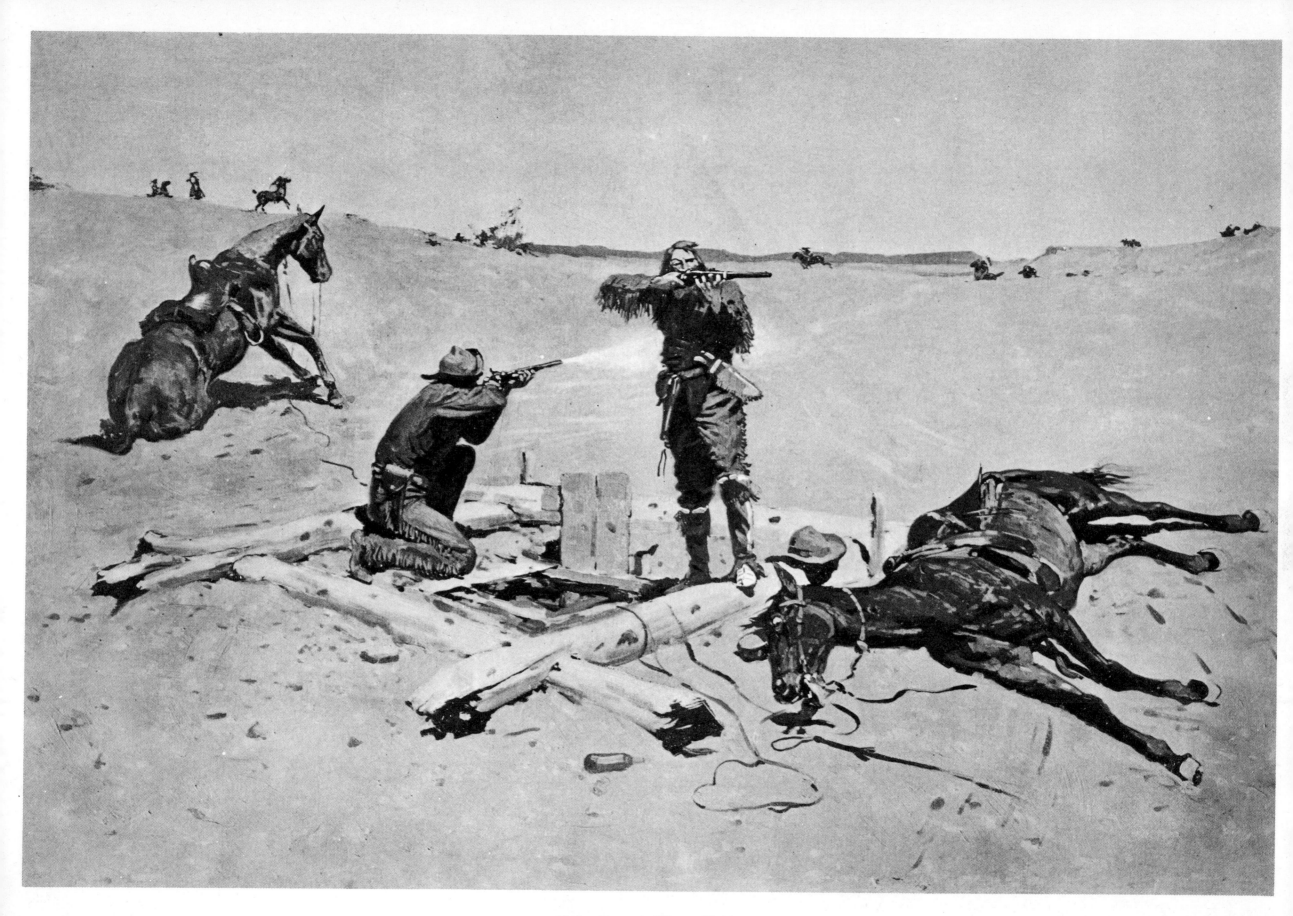

Fight Over a Water Hole.

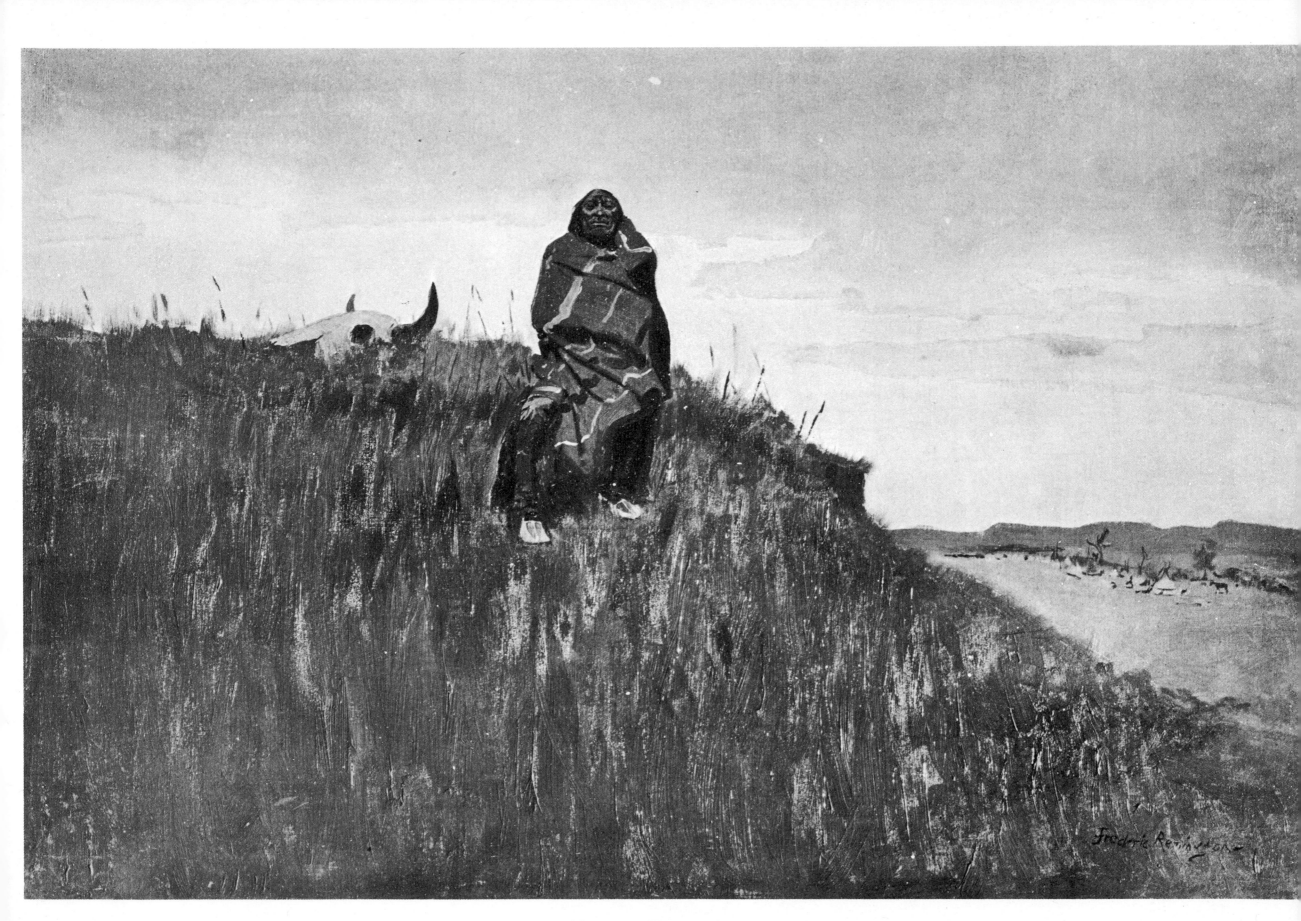

When His Heart is Bad.

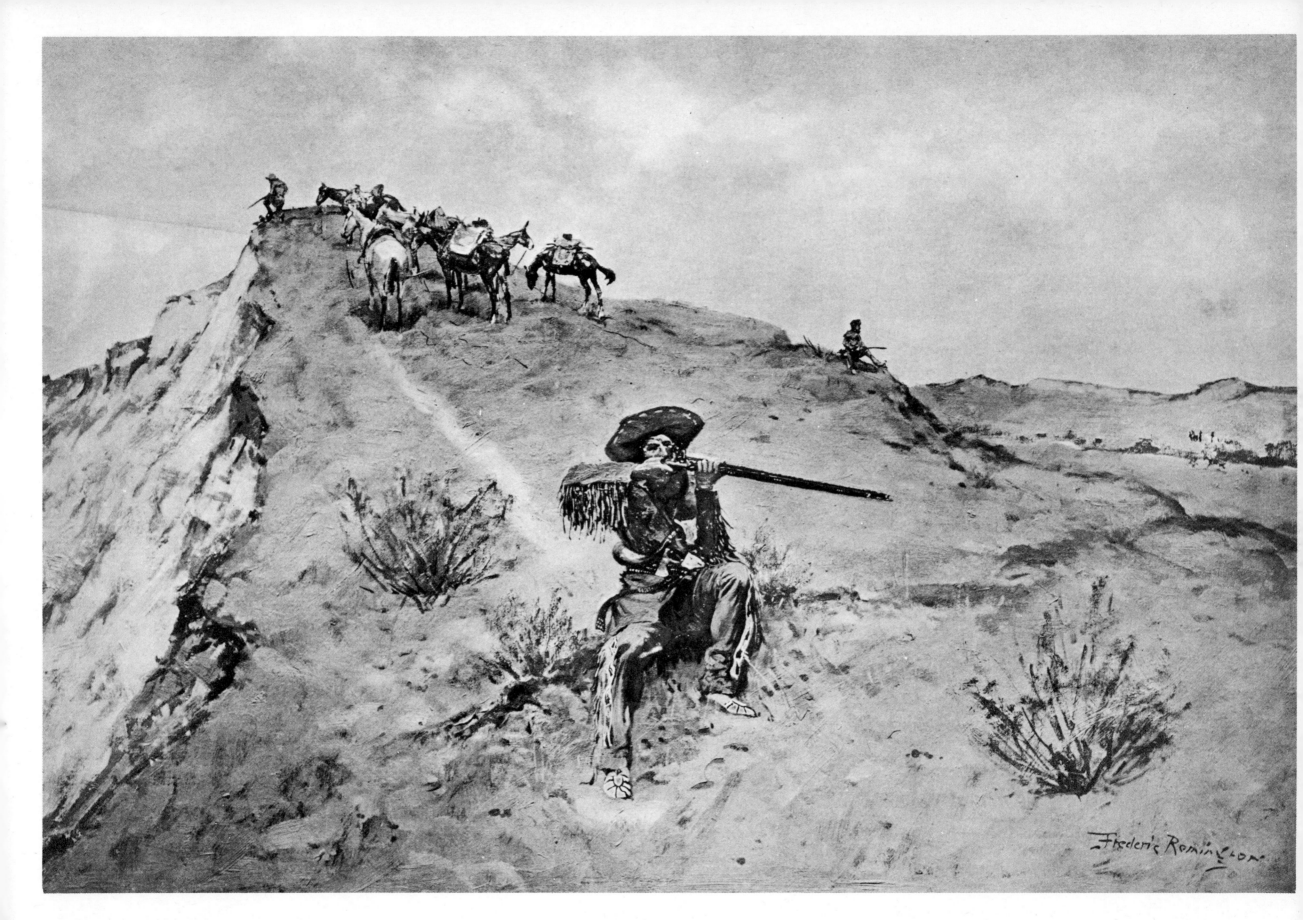

A Citadel of the Plains.

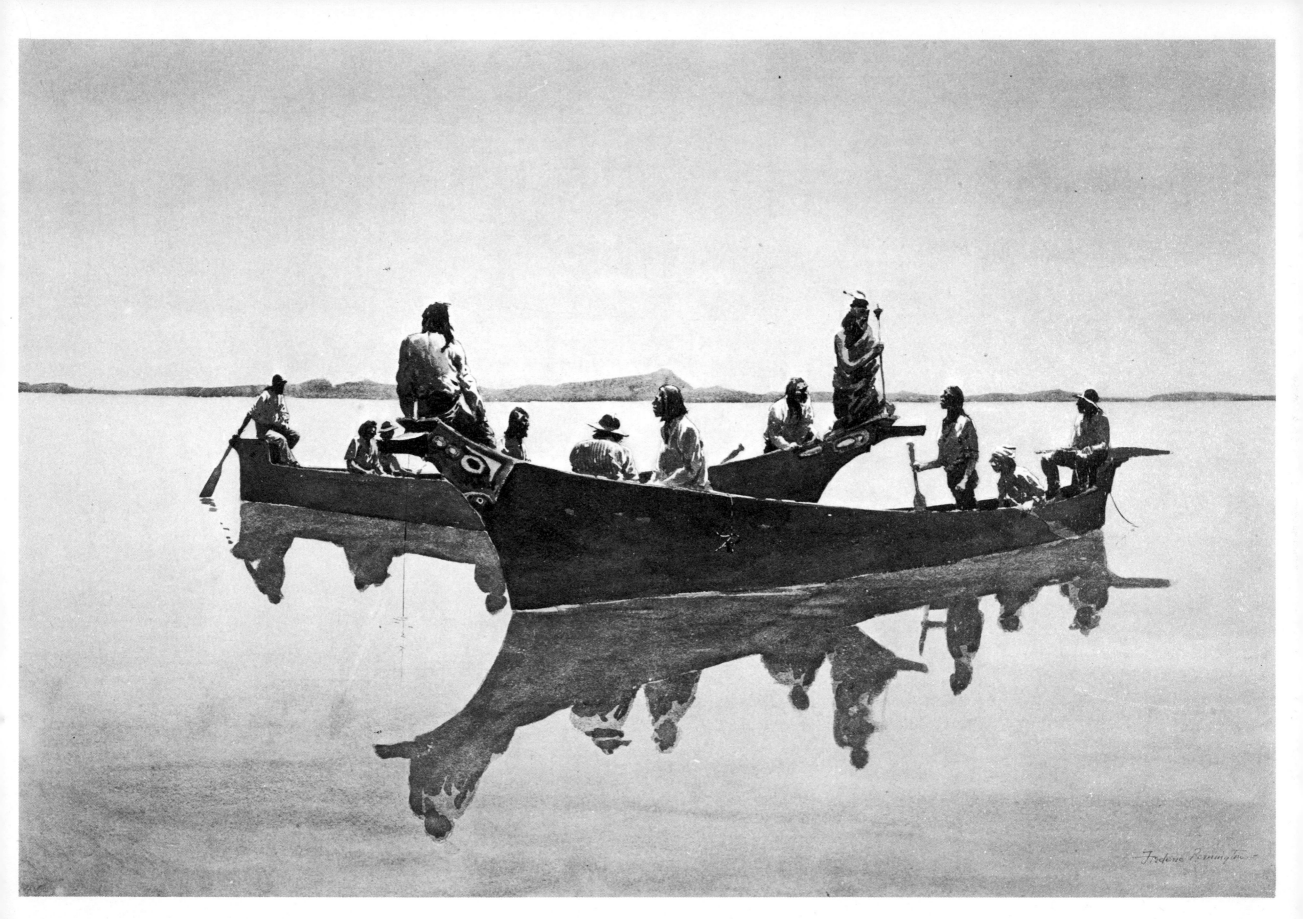

On the Northwest Coast.

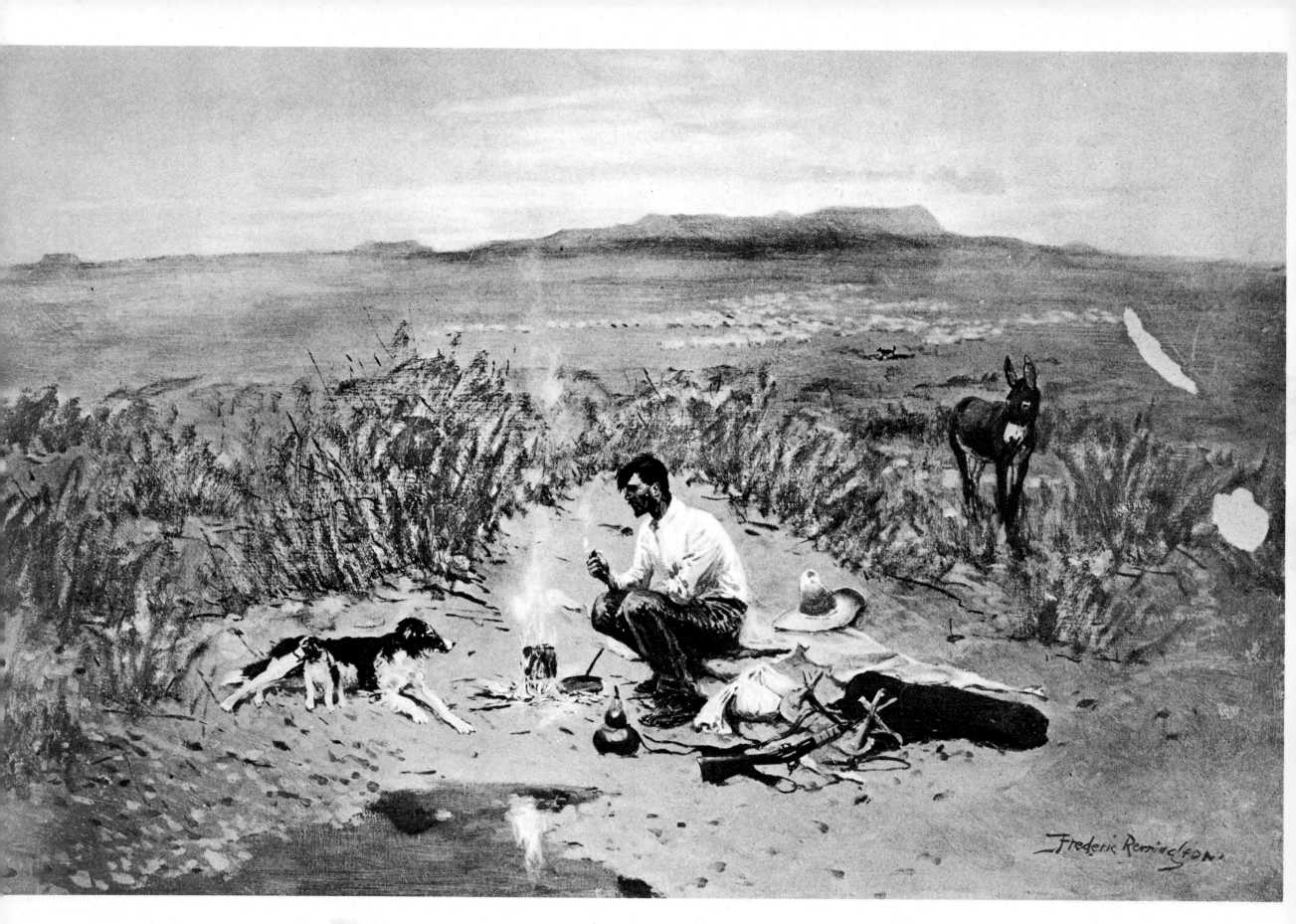

The Sheep Herder's Breakfast.

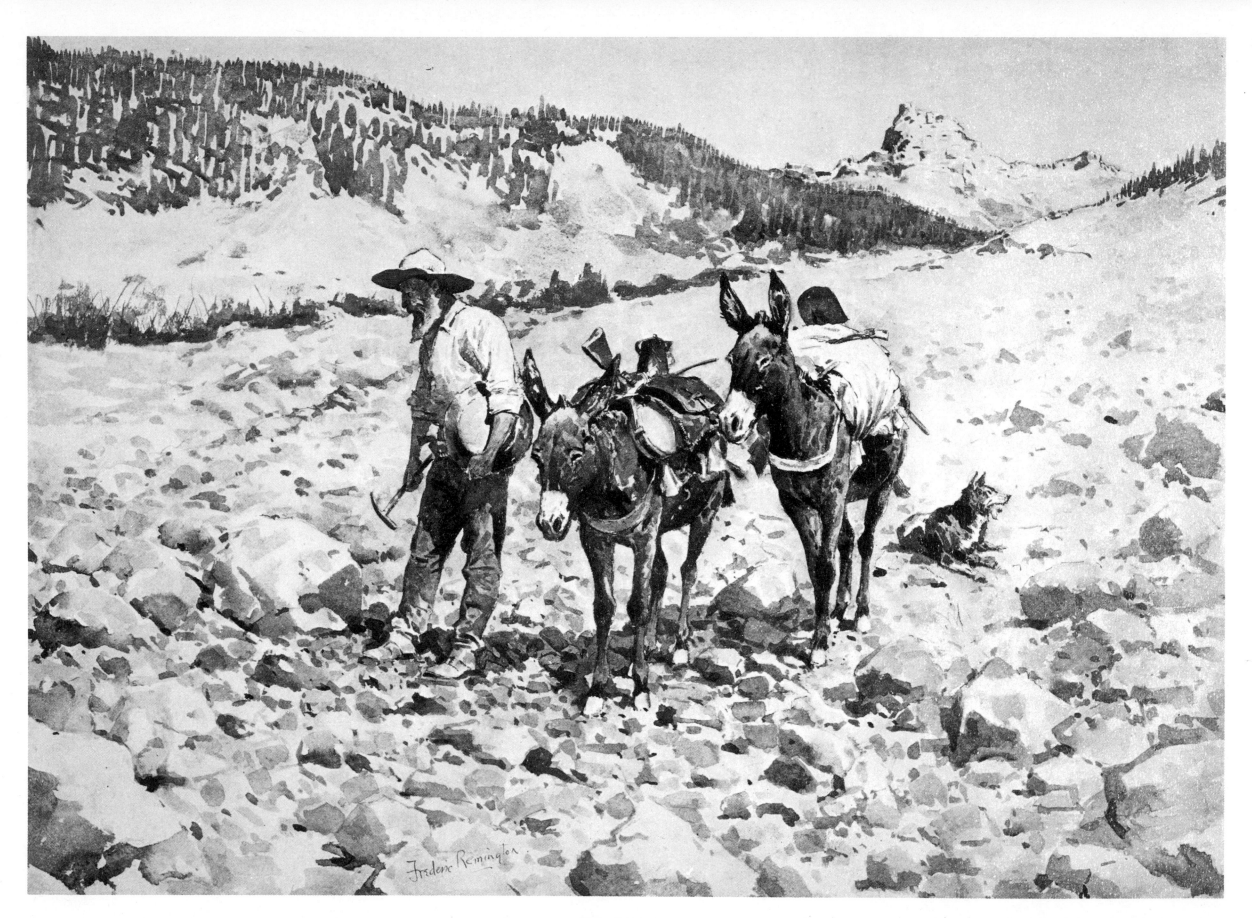

The Gold Bug.

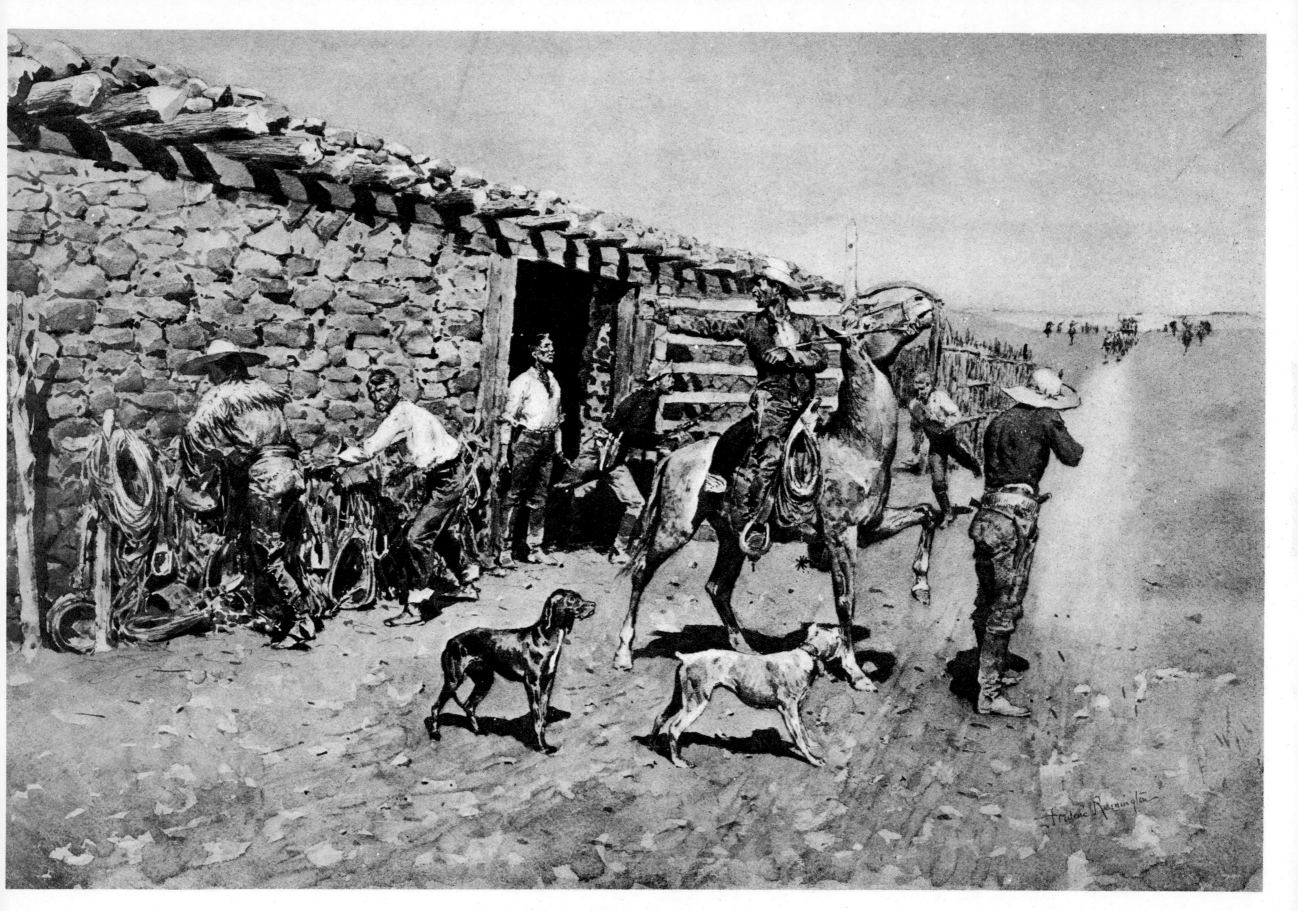

An Overland Station: Indians Coming in with the Stage.

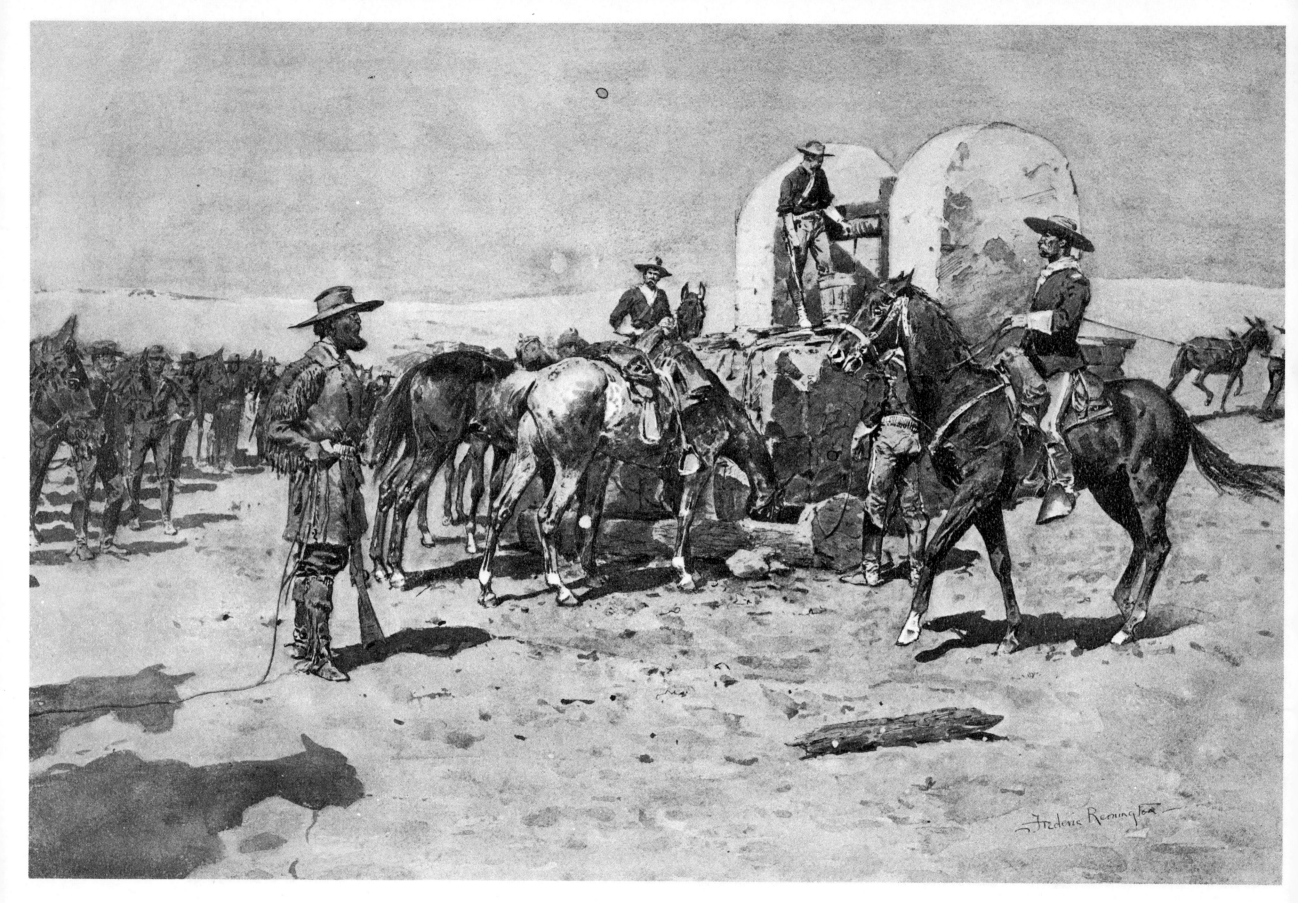

The Well in the Desert.

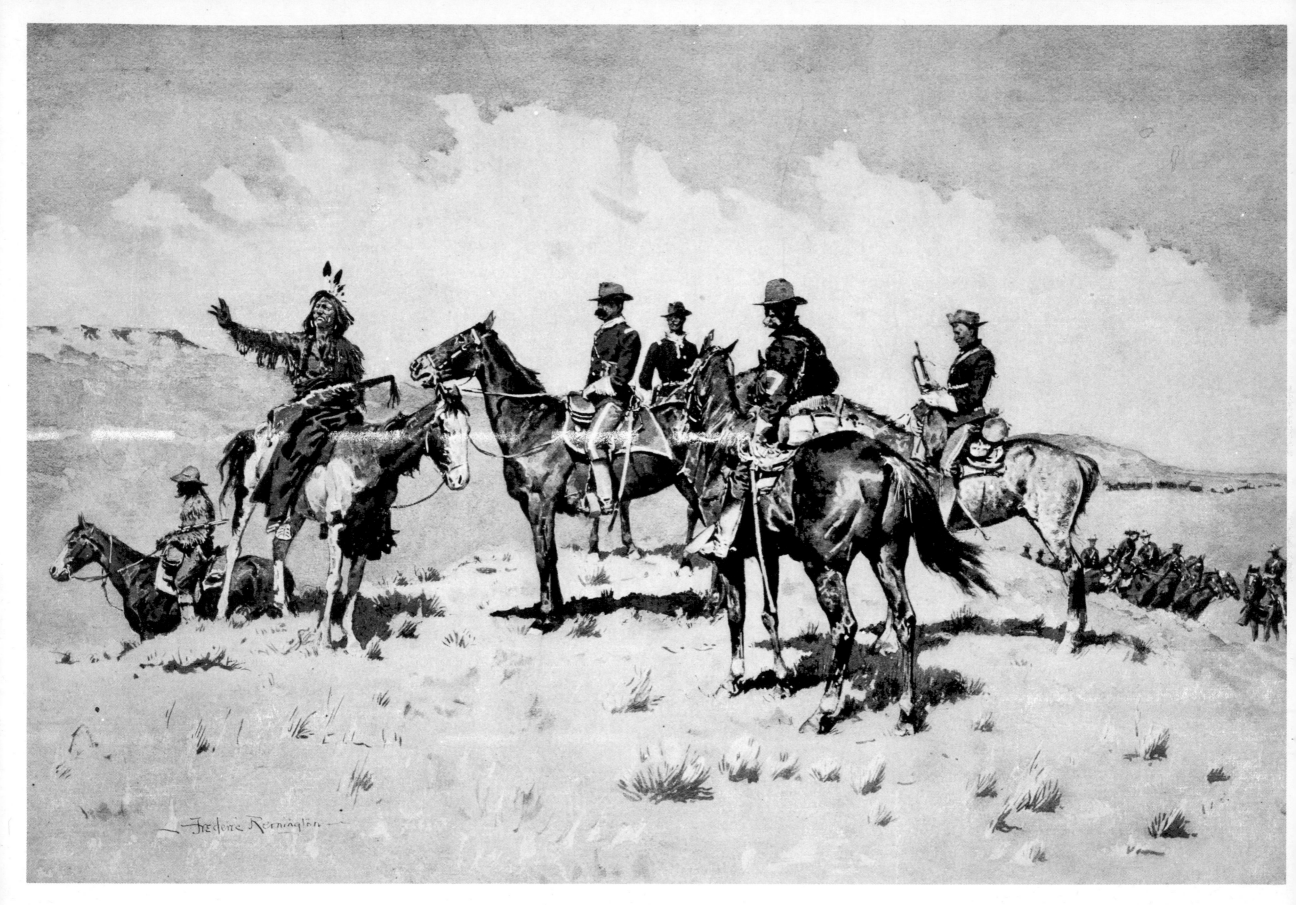

The Borderland of the Other Tribe.

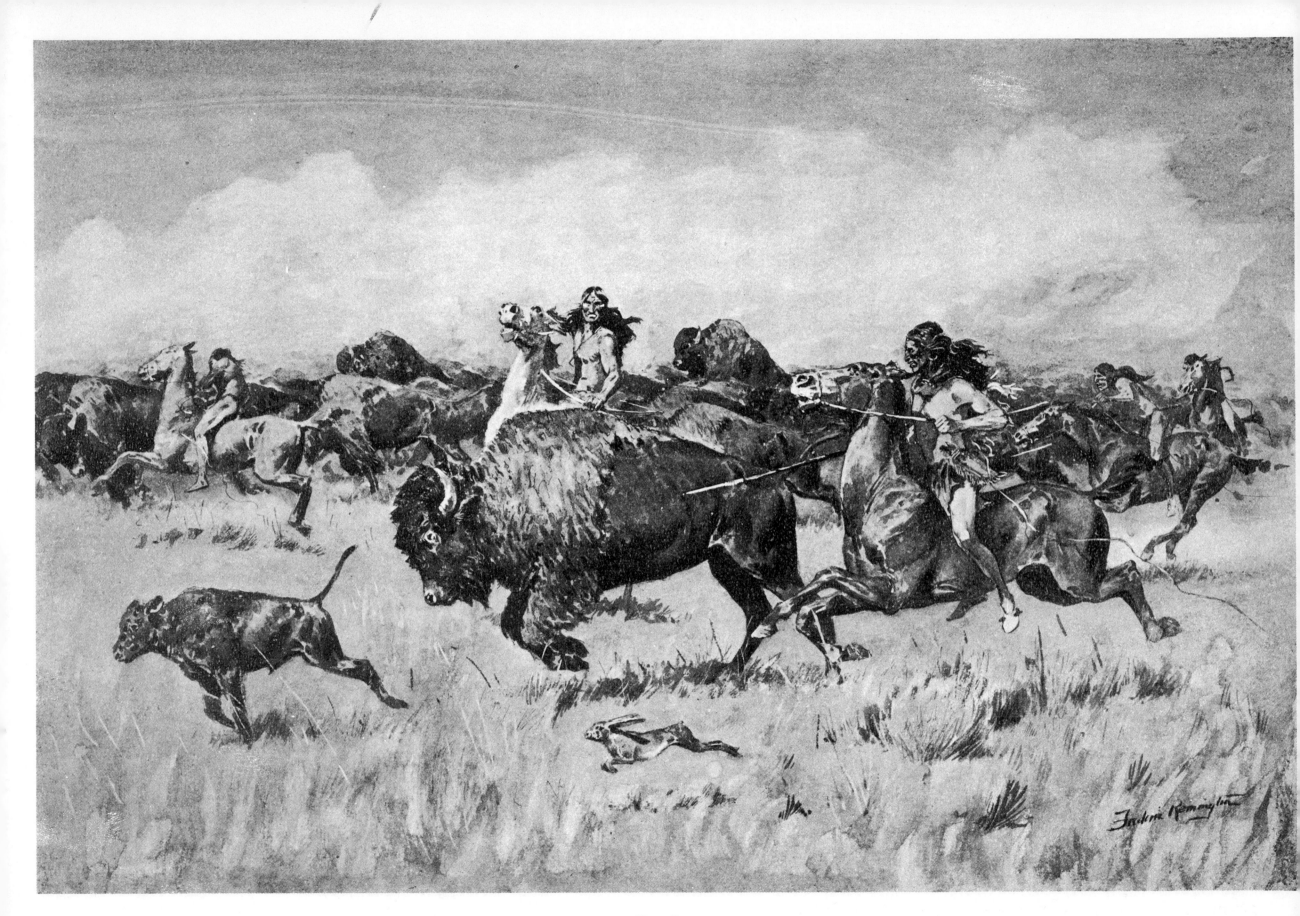

Her Calf.

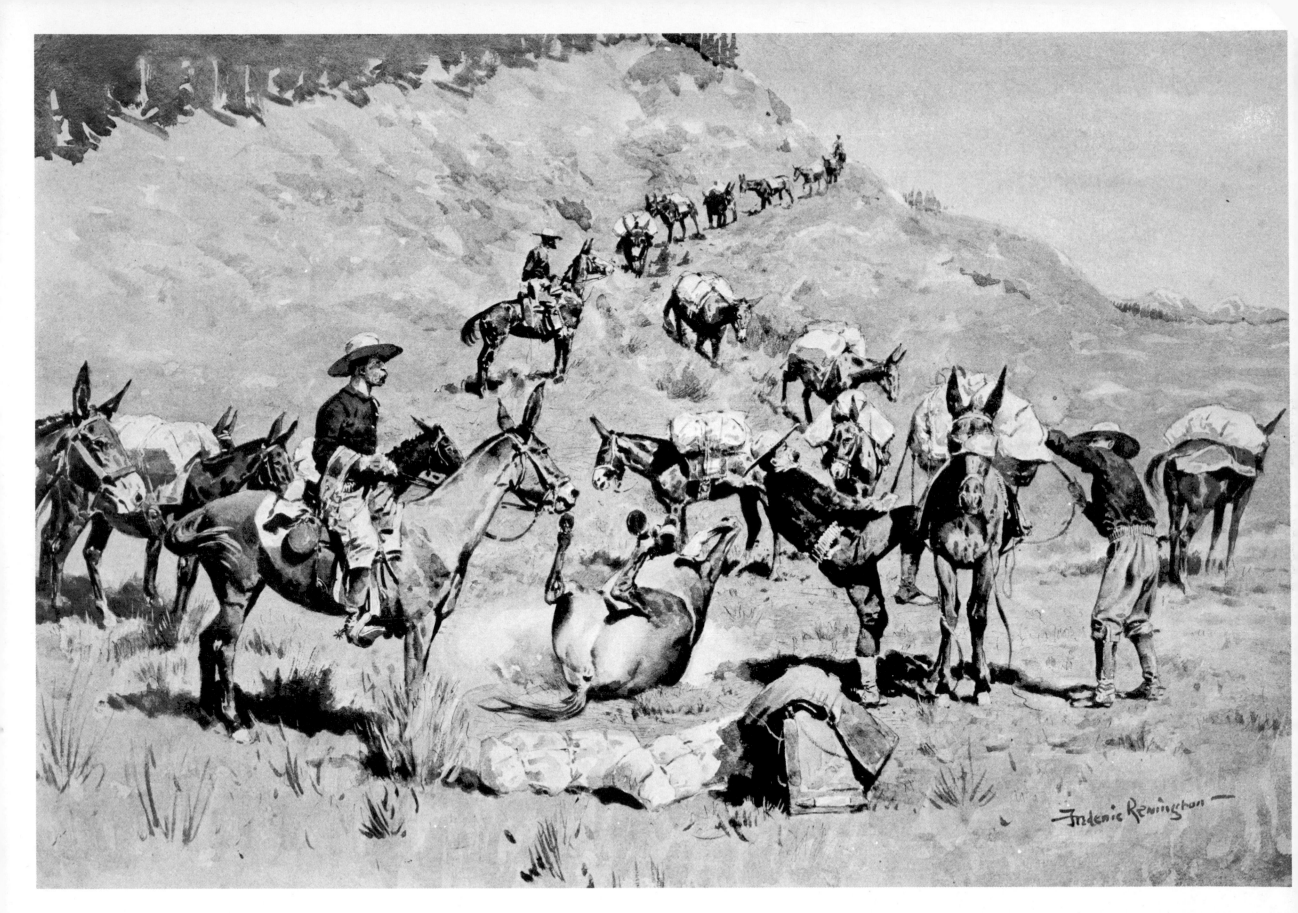

A Government Pack Train.

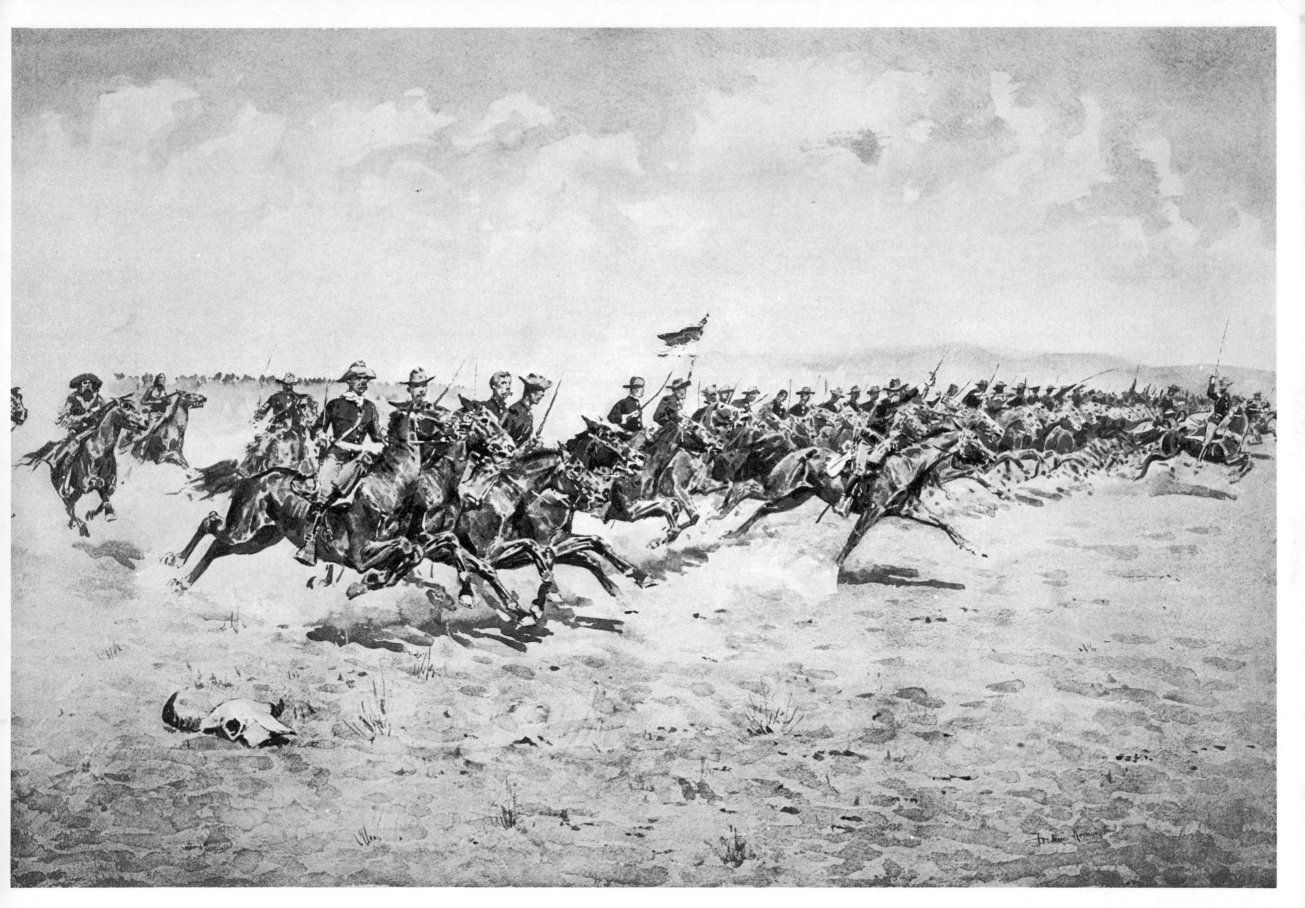

The Charge.

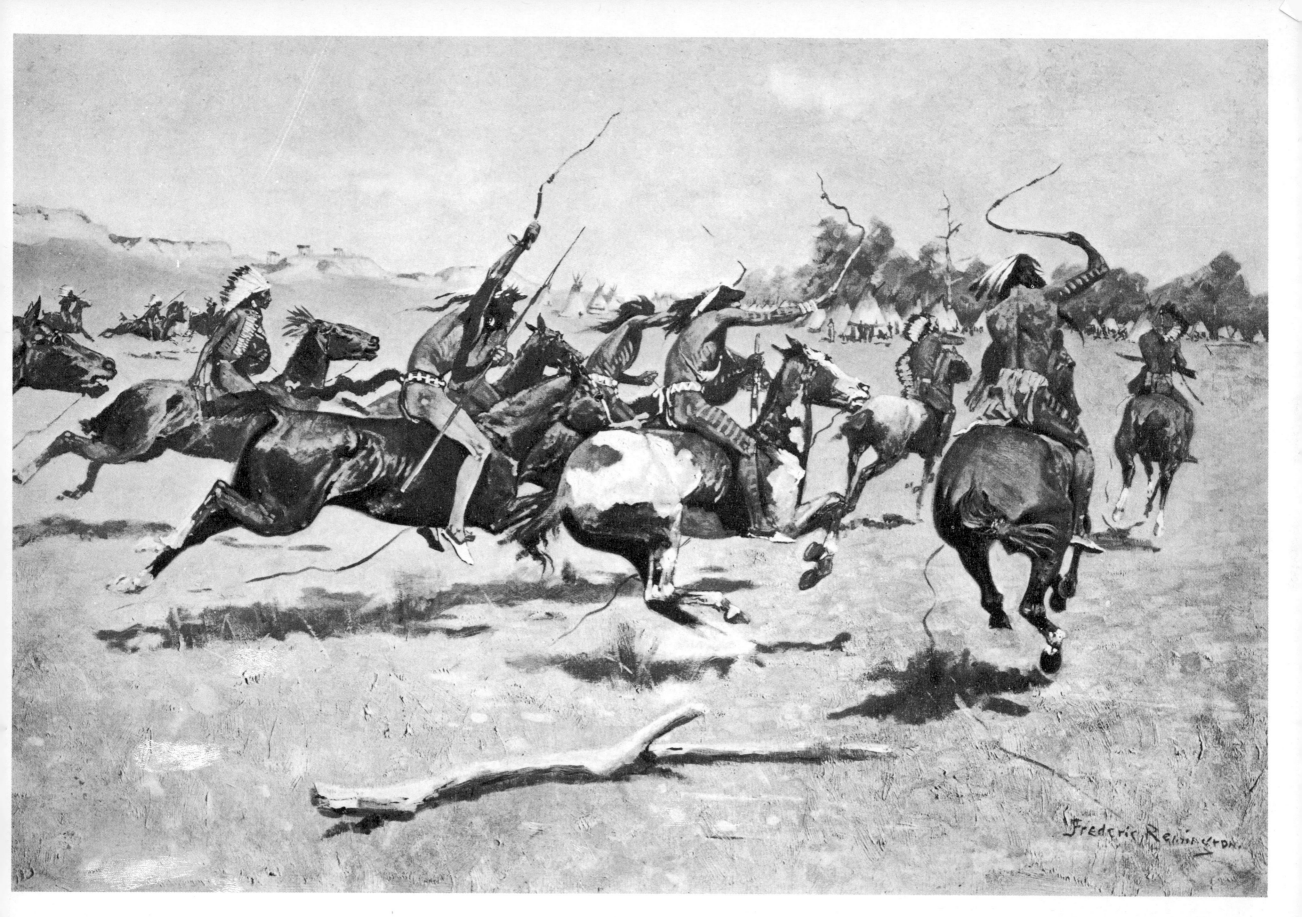

The Pony War-Dance.

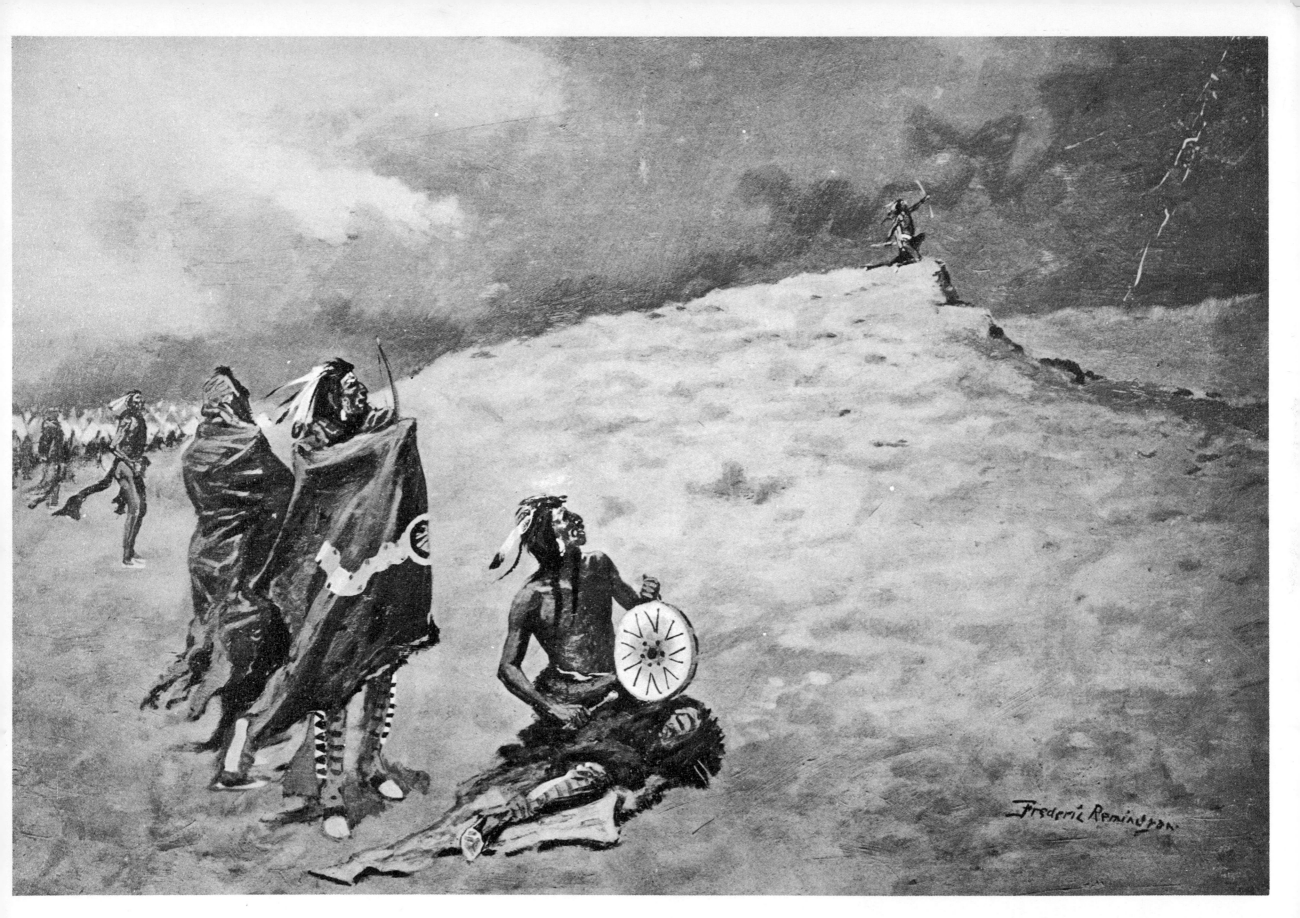

The Coming Storm.

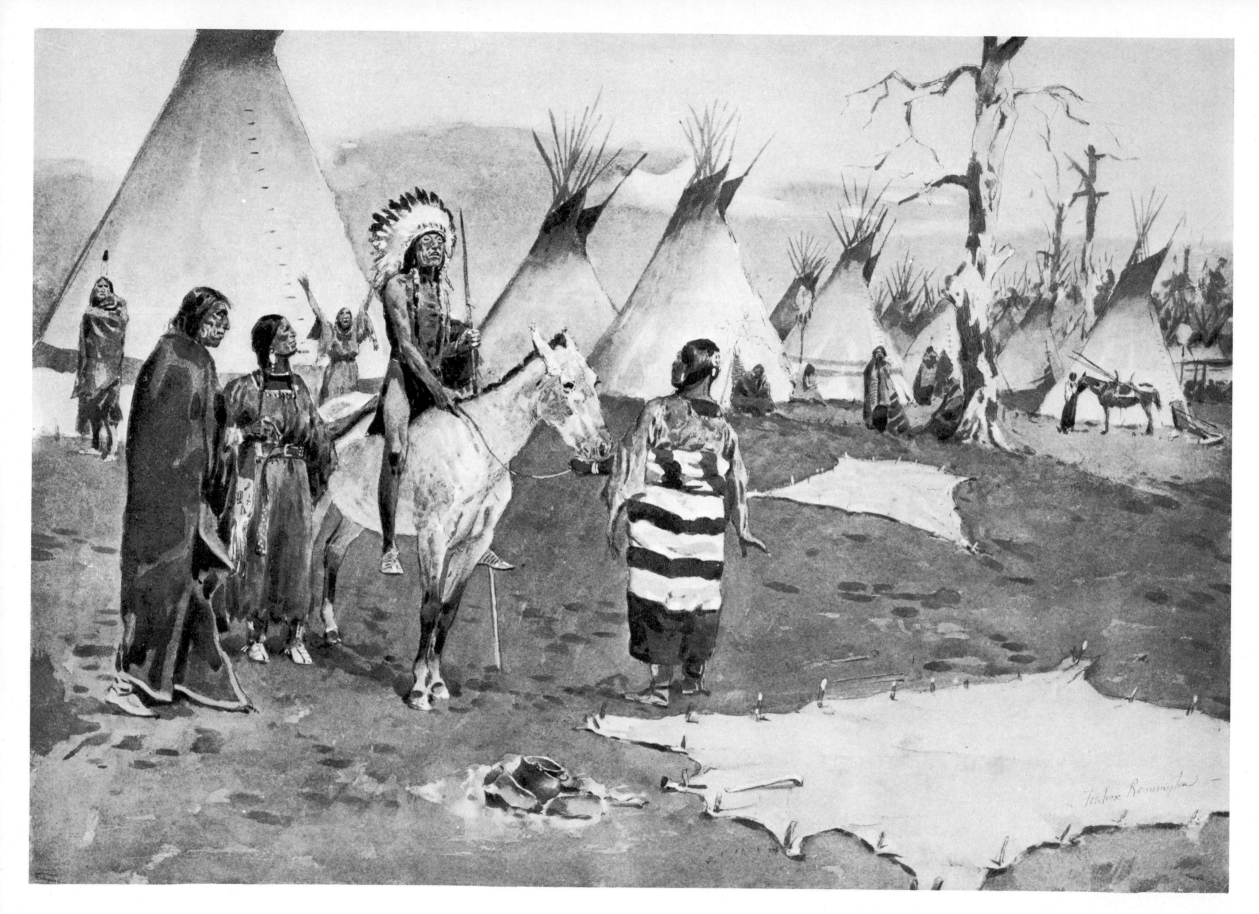

His Death Song.

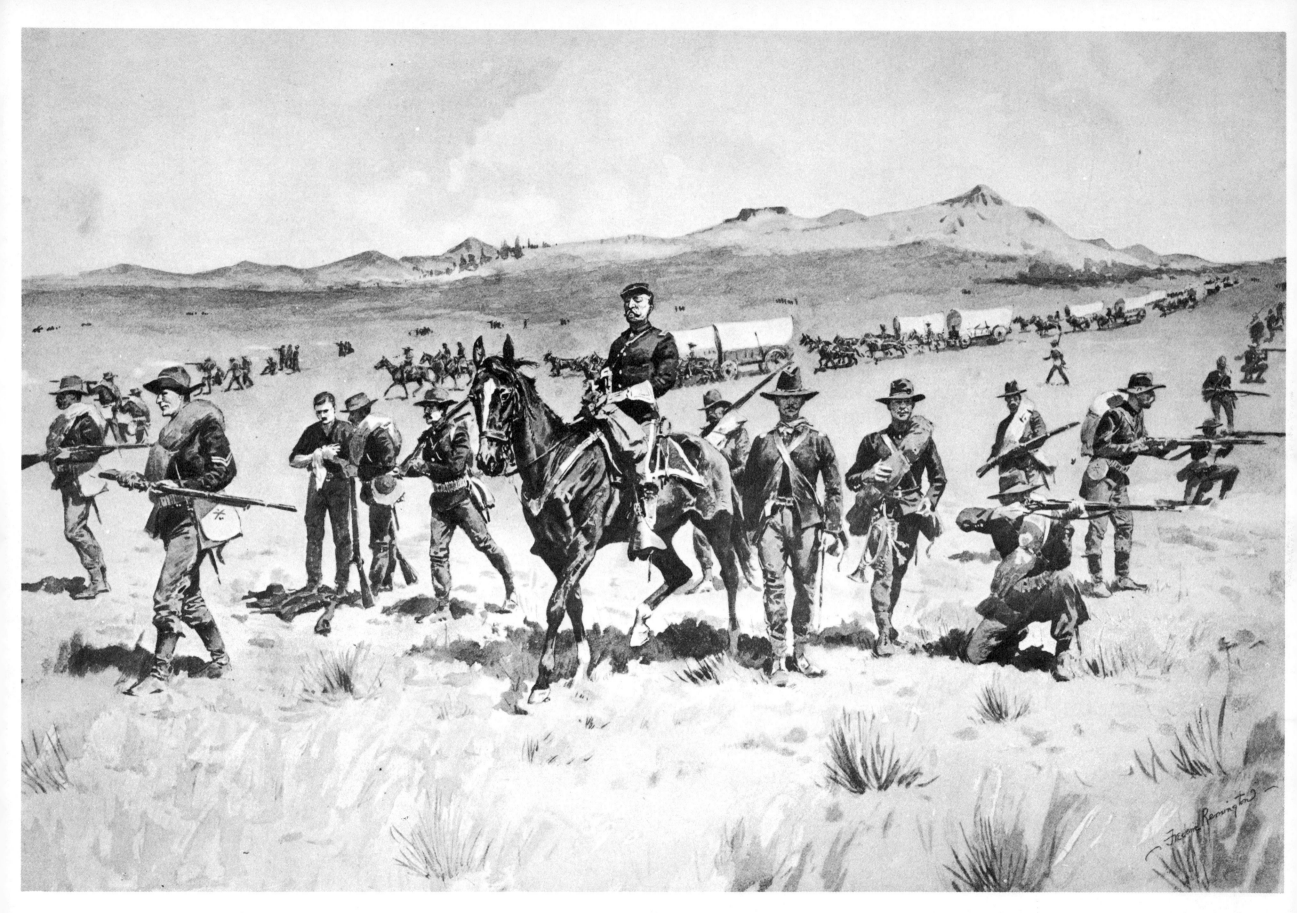

Protecting a Wagon Train.

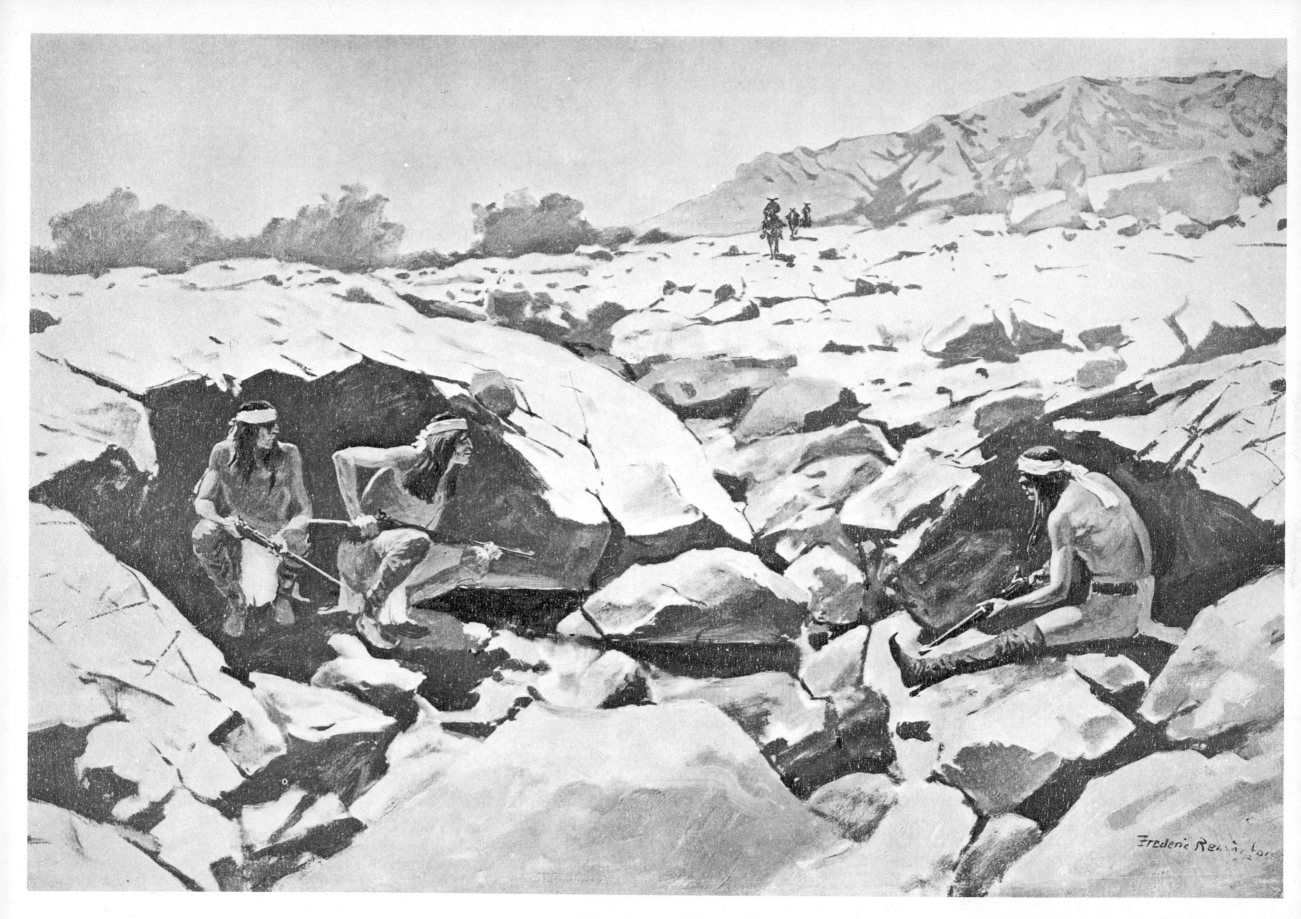

The Water in Arizona.

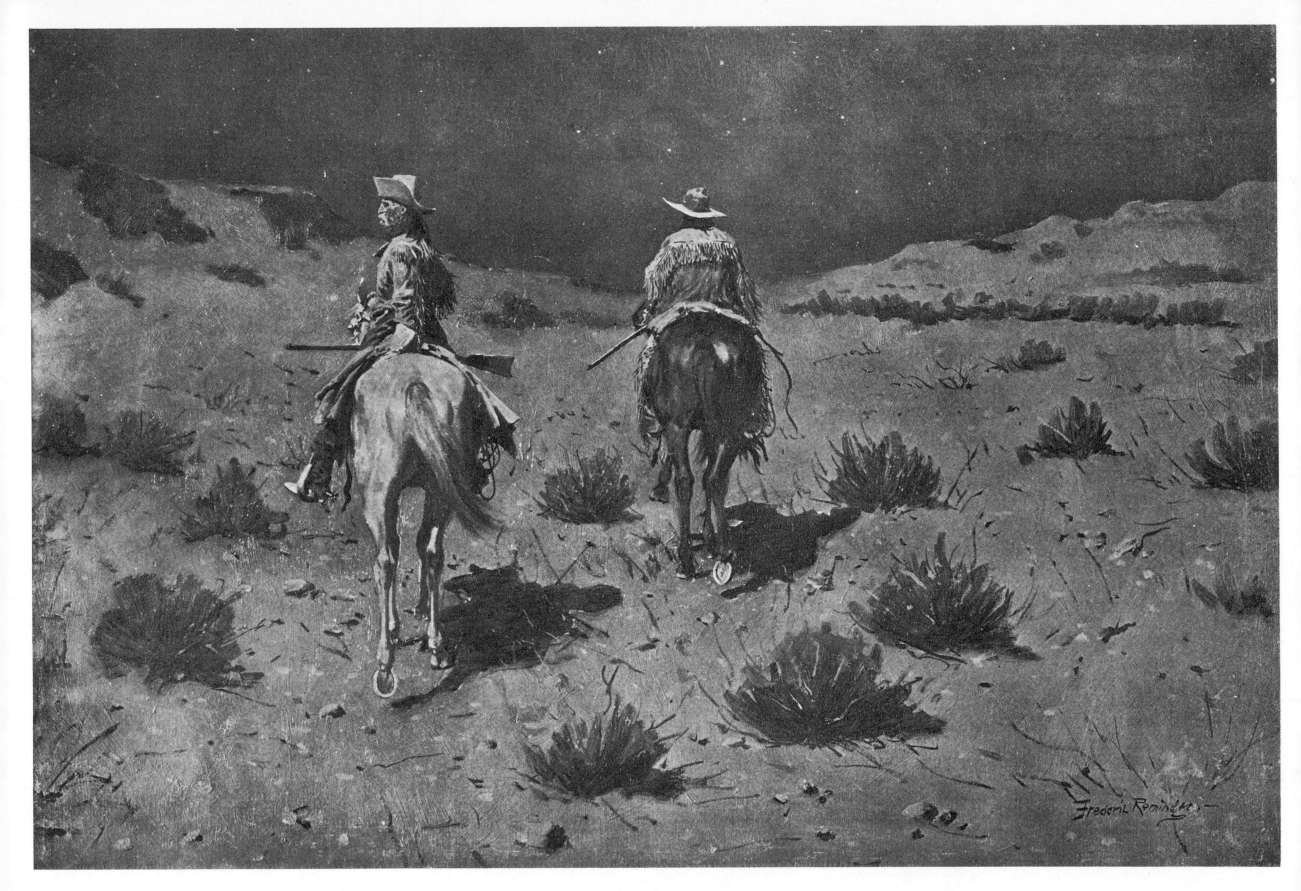

Government Scouts—Moonlight.

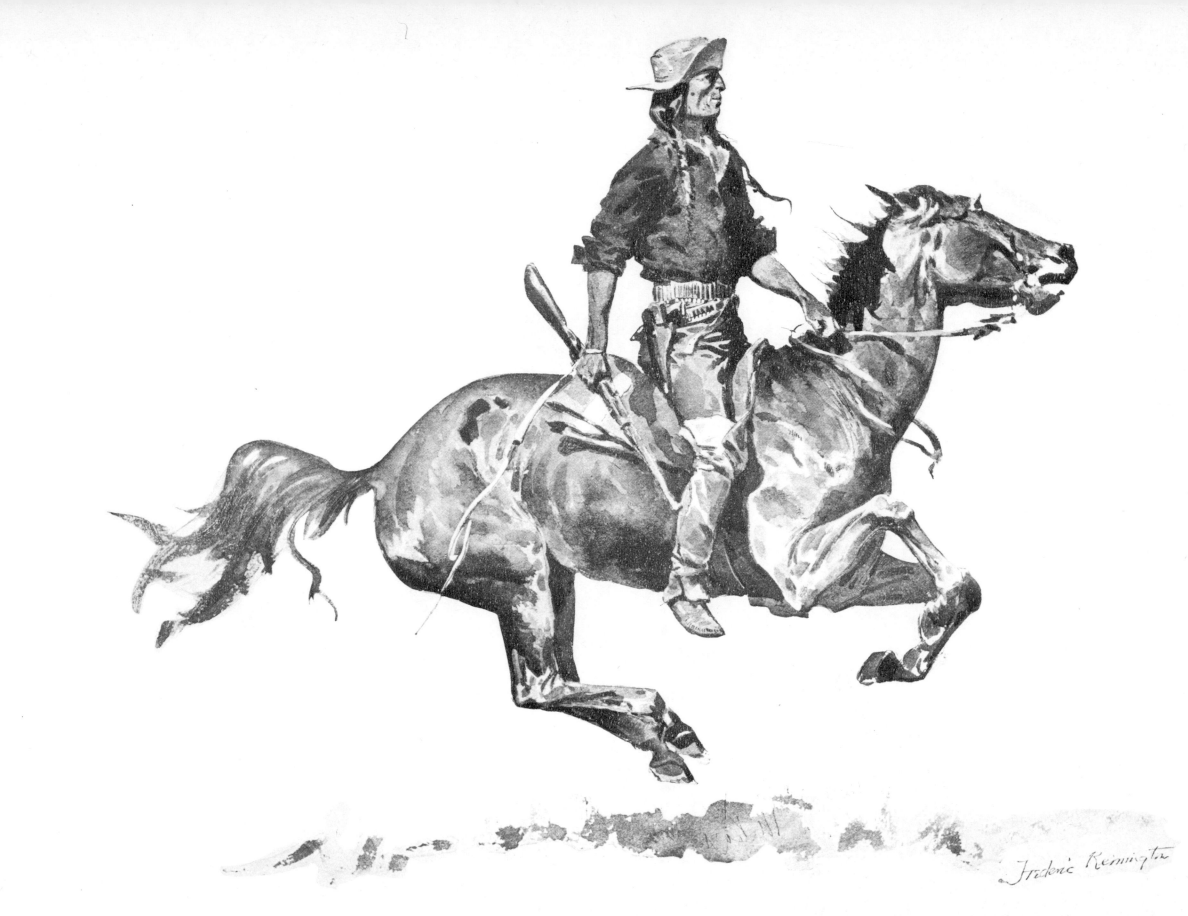

A Crow Scout.

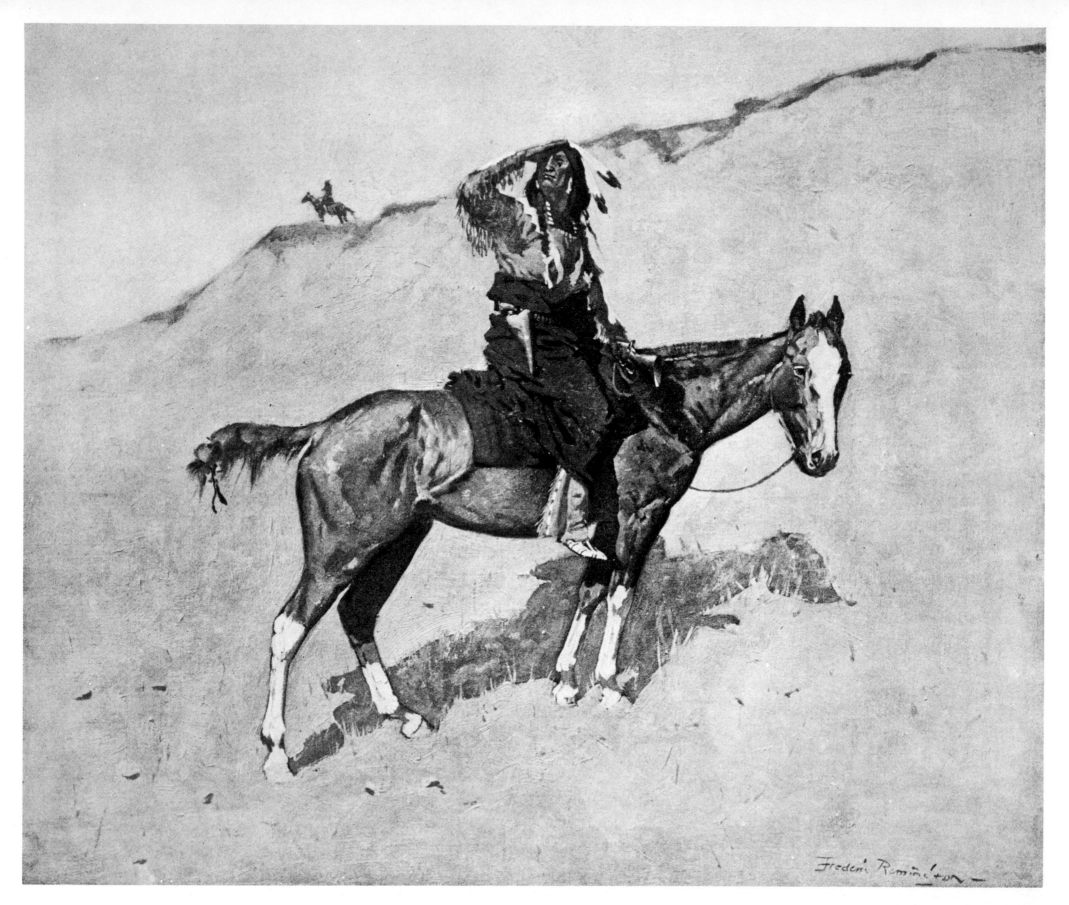

Hostiles Watching the Column.

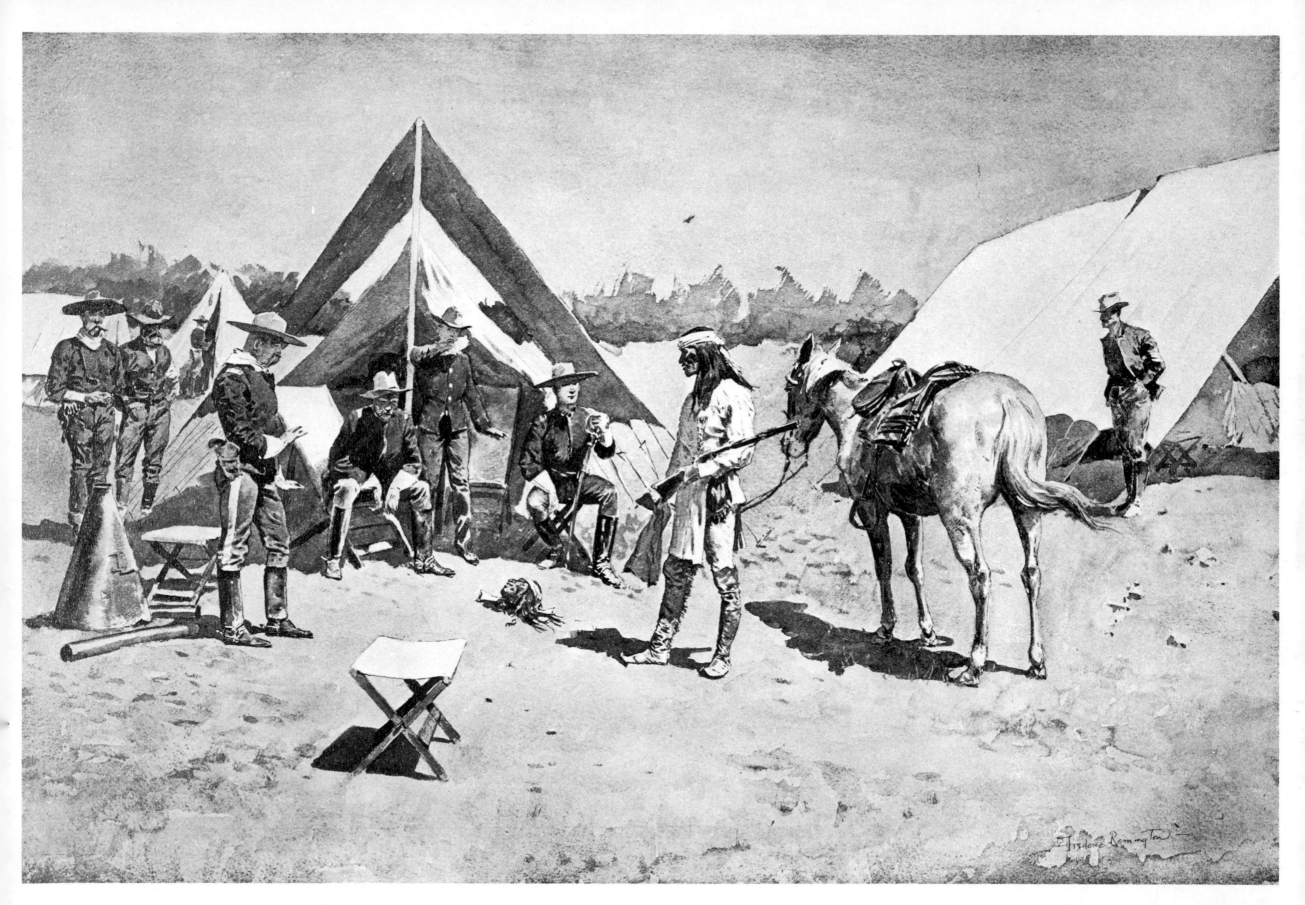

Satisfying the Demands of Justice: The Head.

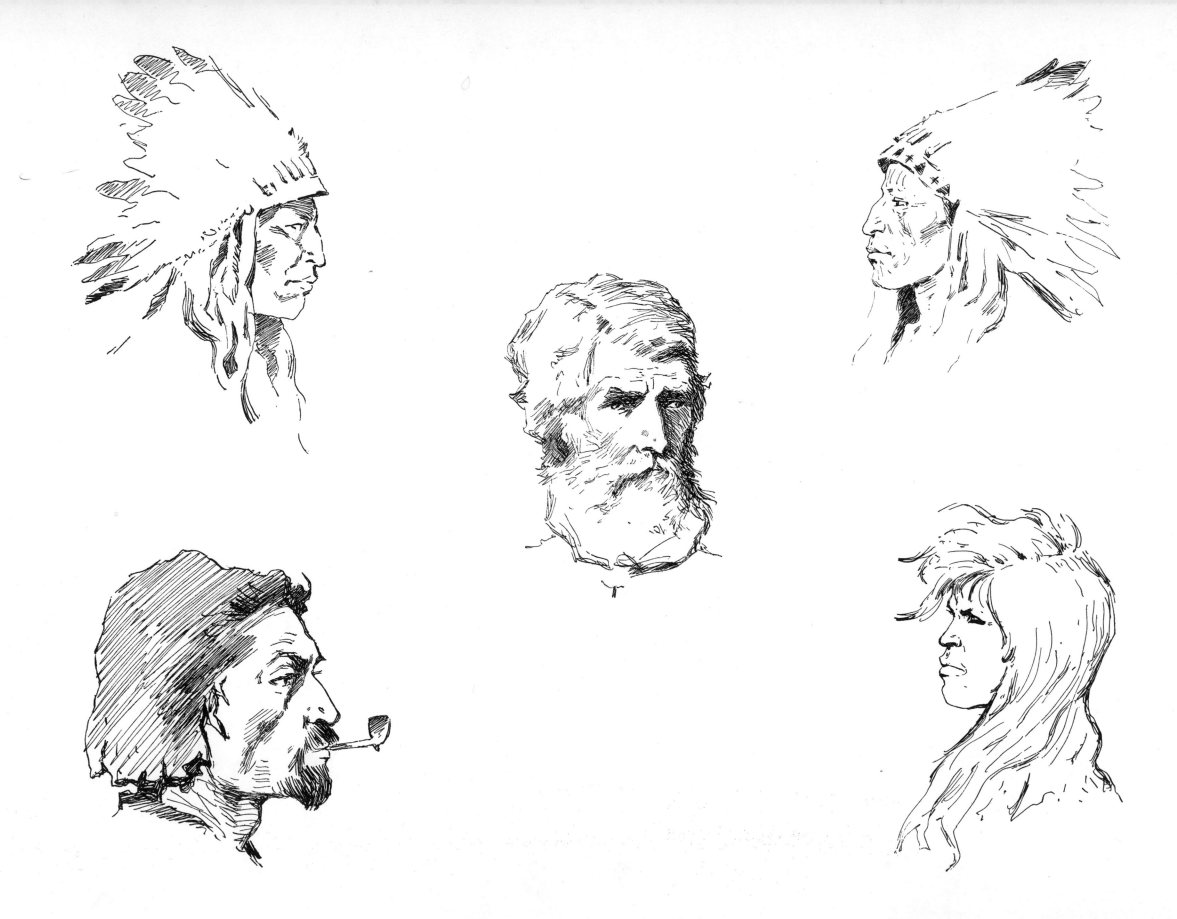

Sketch-Book Notes.

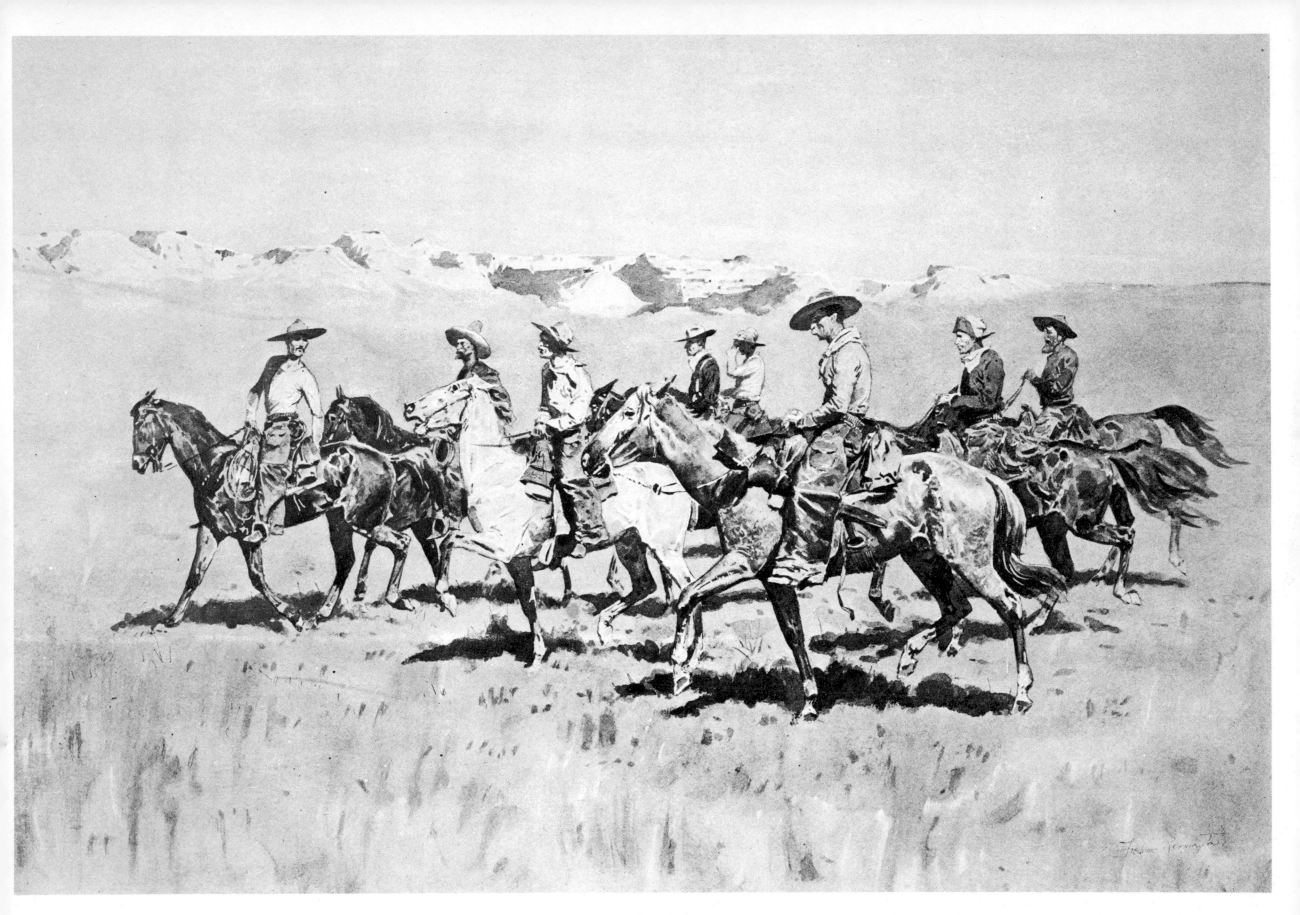

The Punchers.

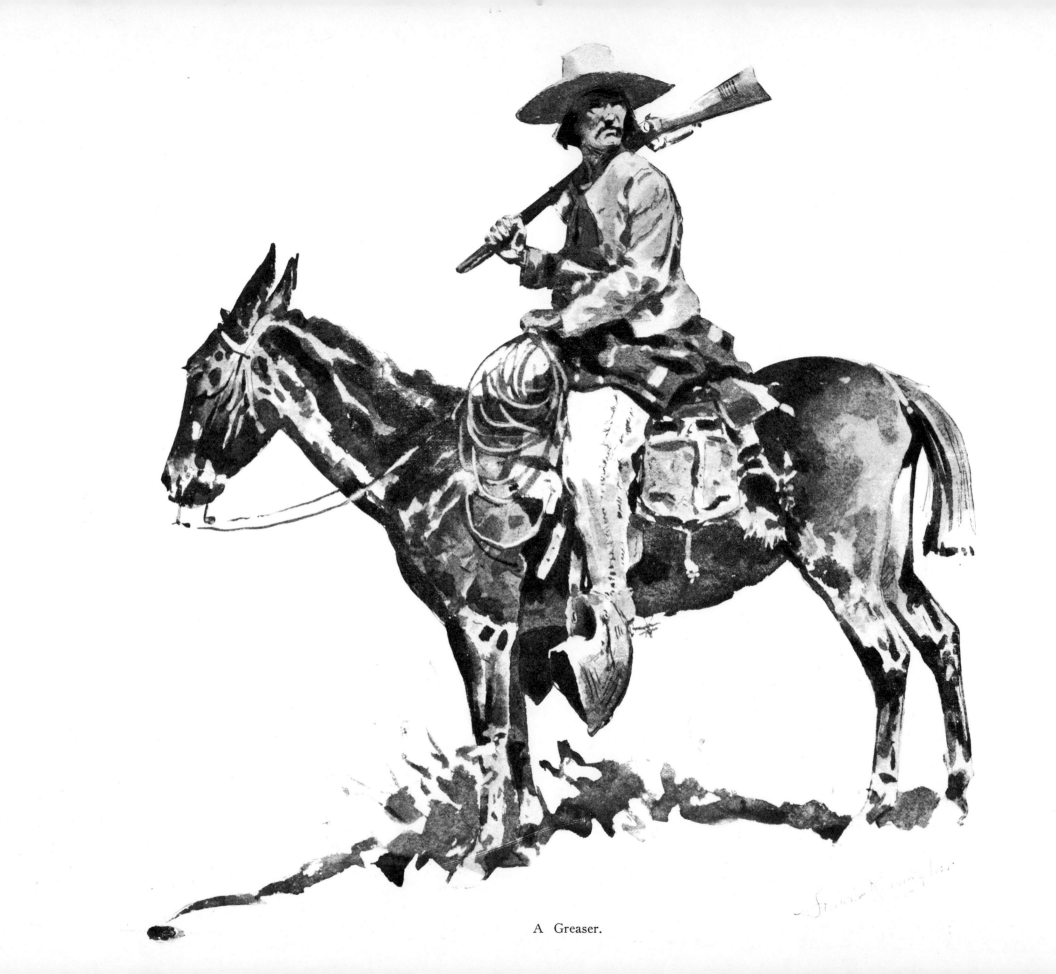

A Greaser.

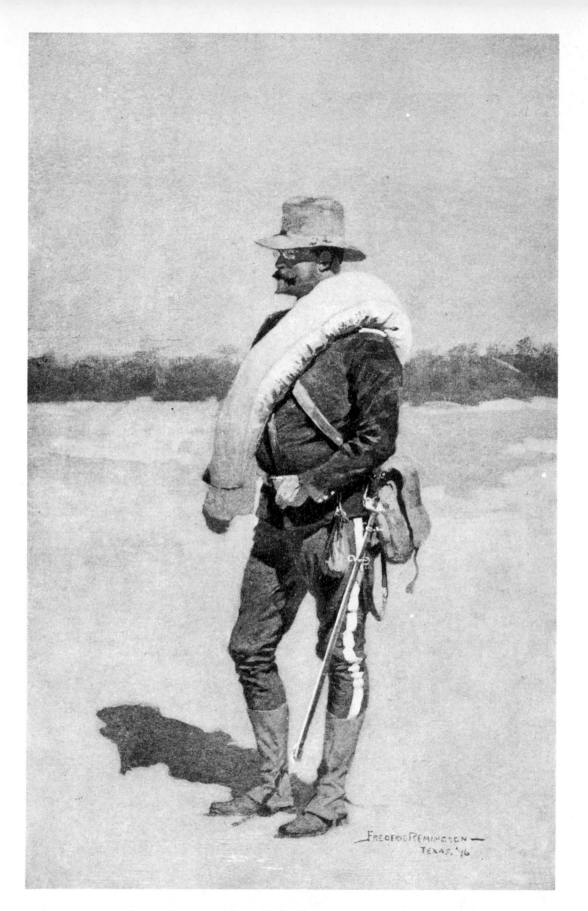

A Captain of Infantry in Field Rig.

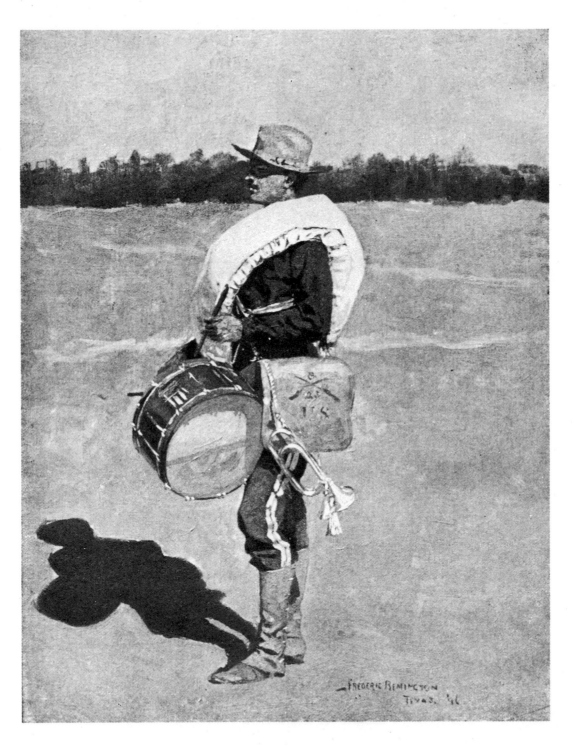

A "Wind Jammer."

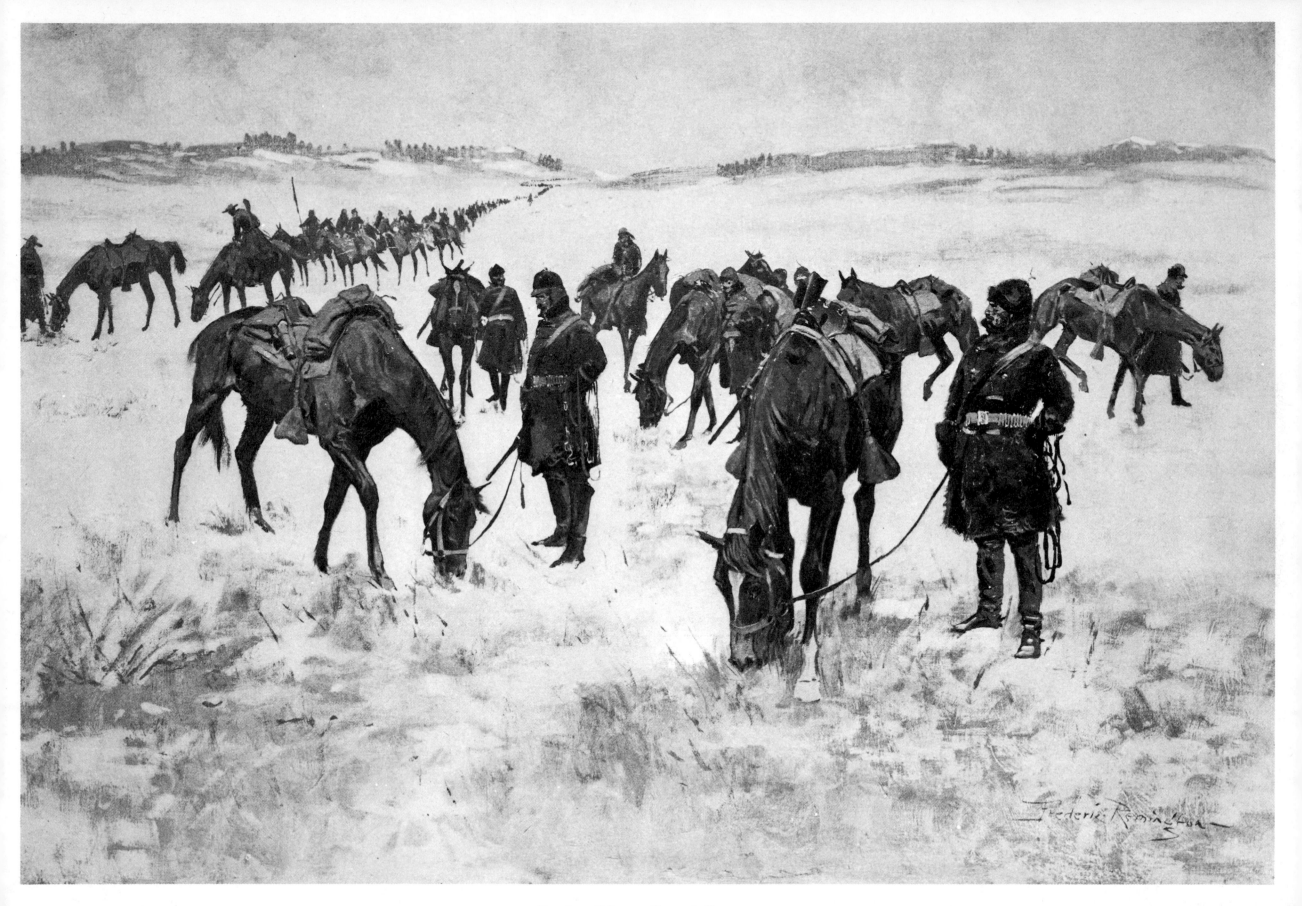

Cavalry Column Out of Forage.

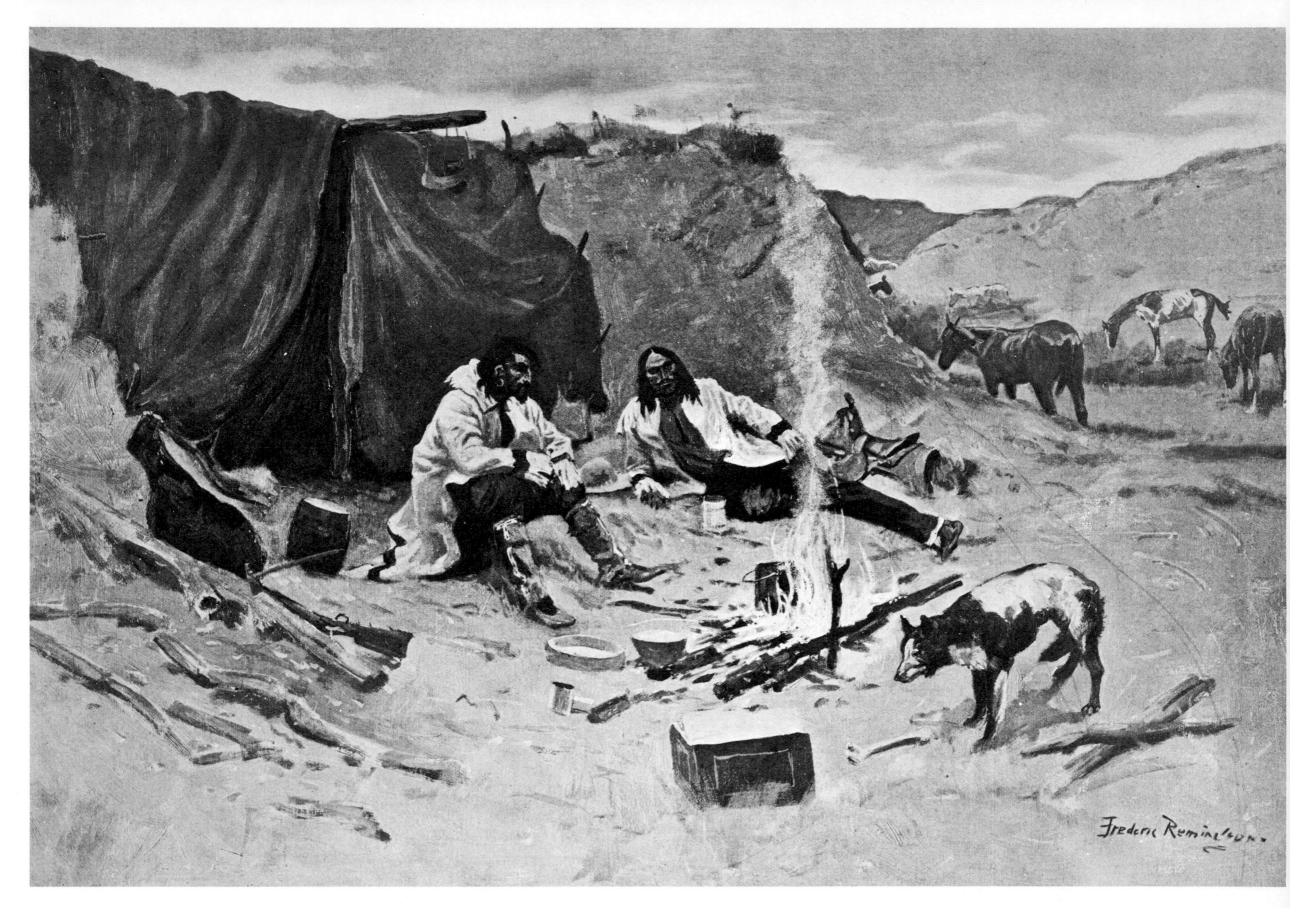

Half-Breed Horse Thieves of the Northwest.

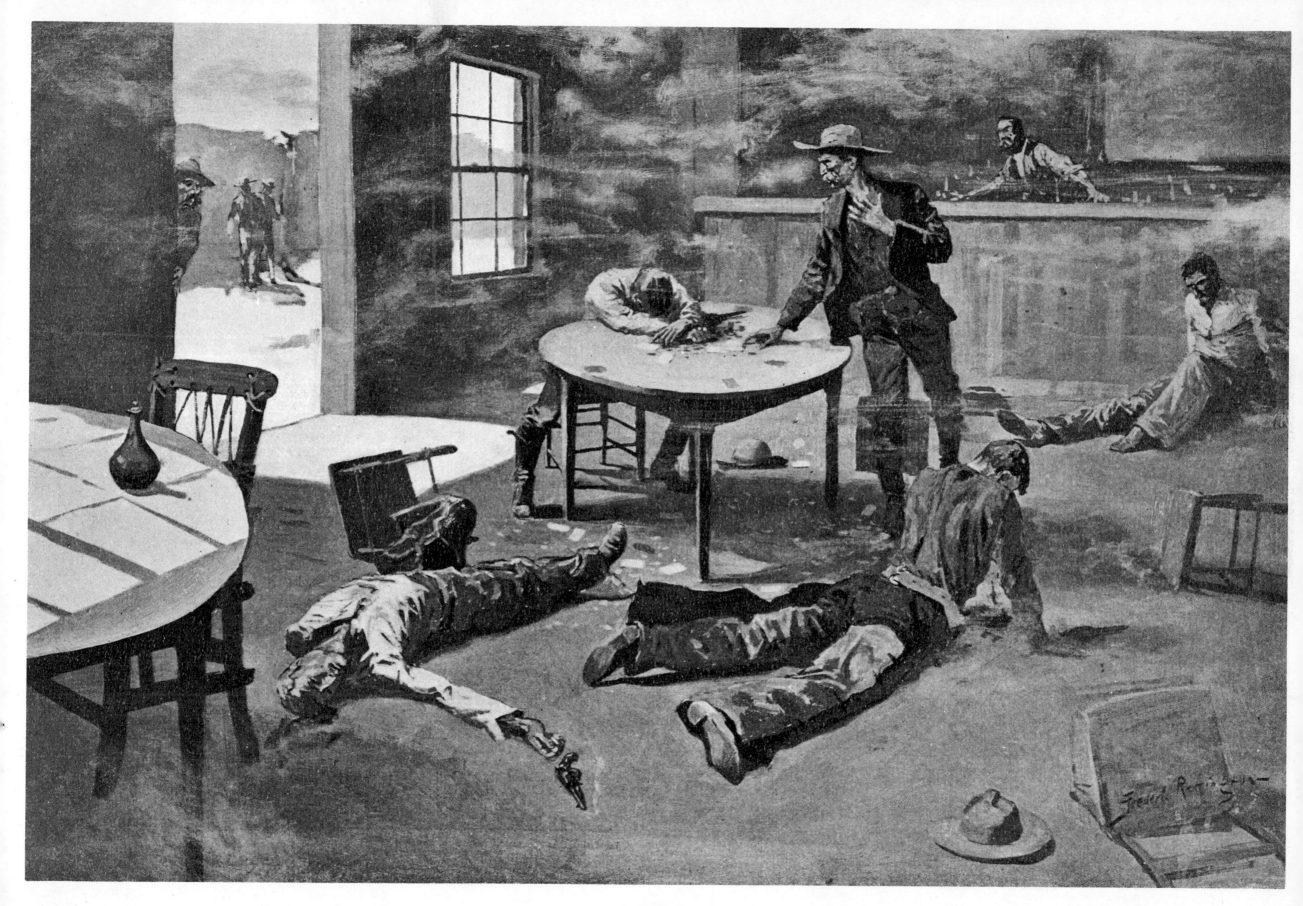

A Misdeal.

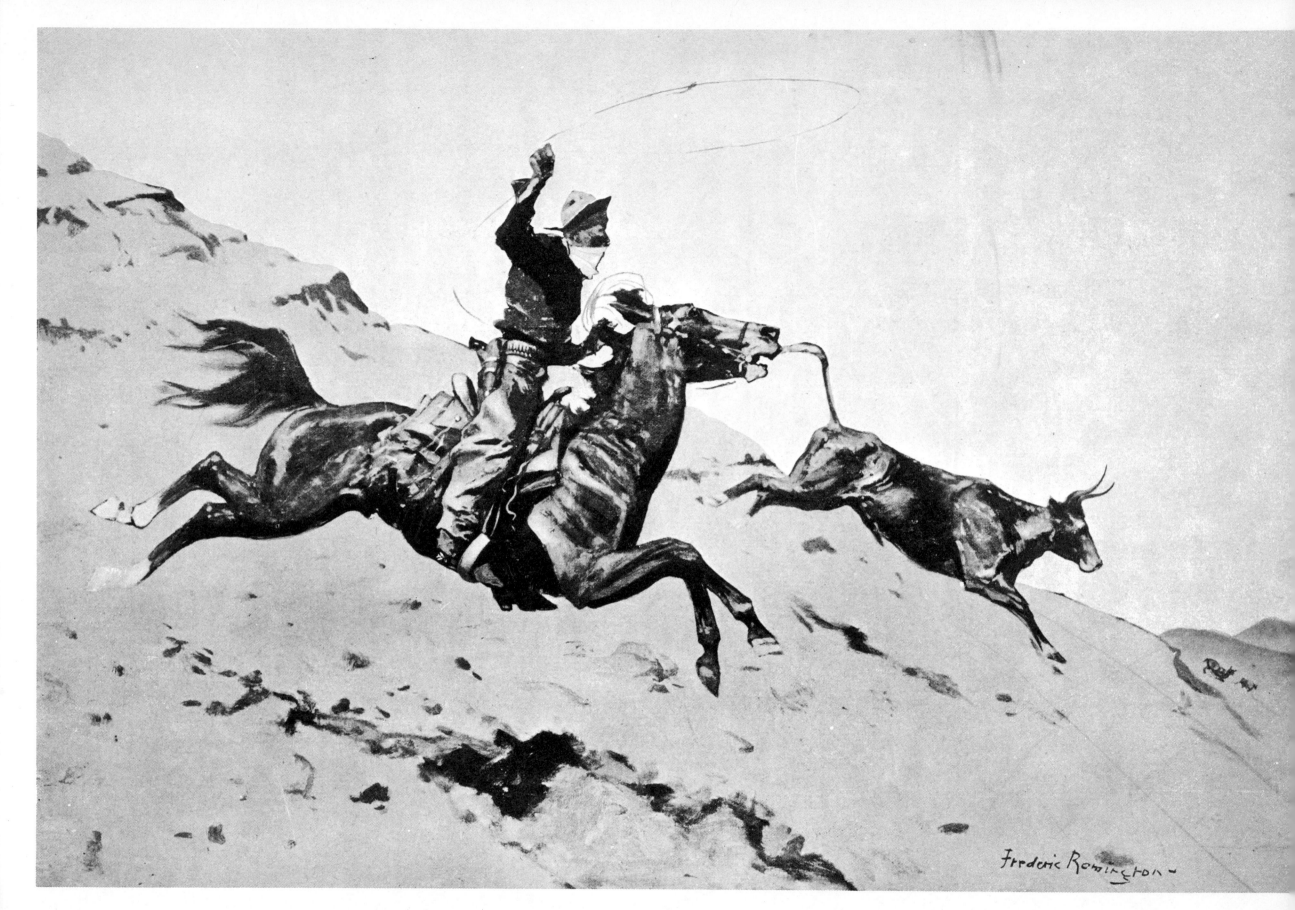

Over the Foot-Hills.

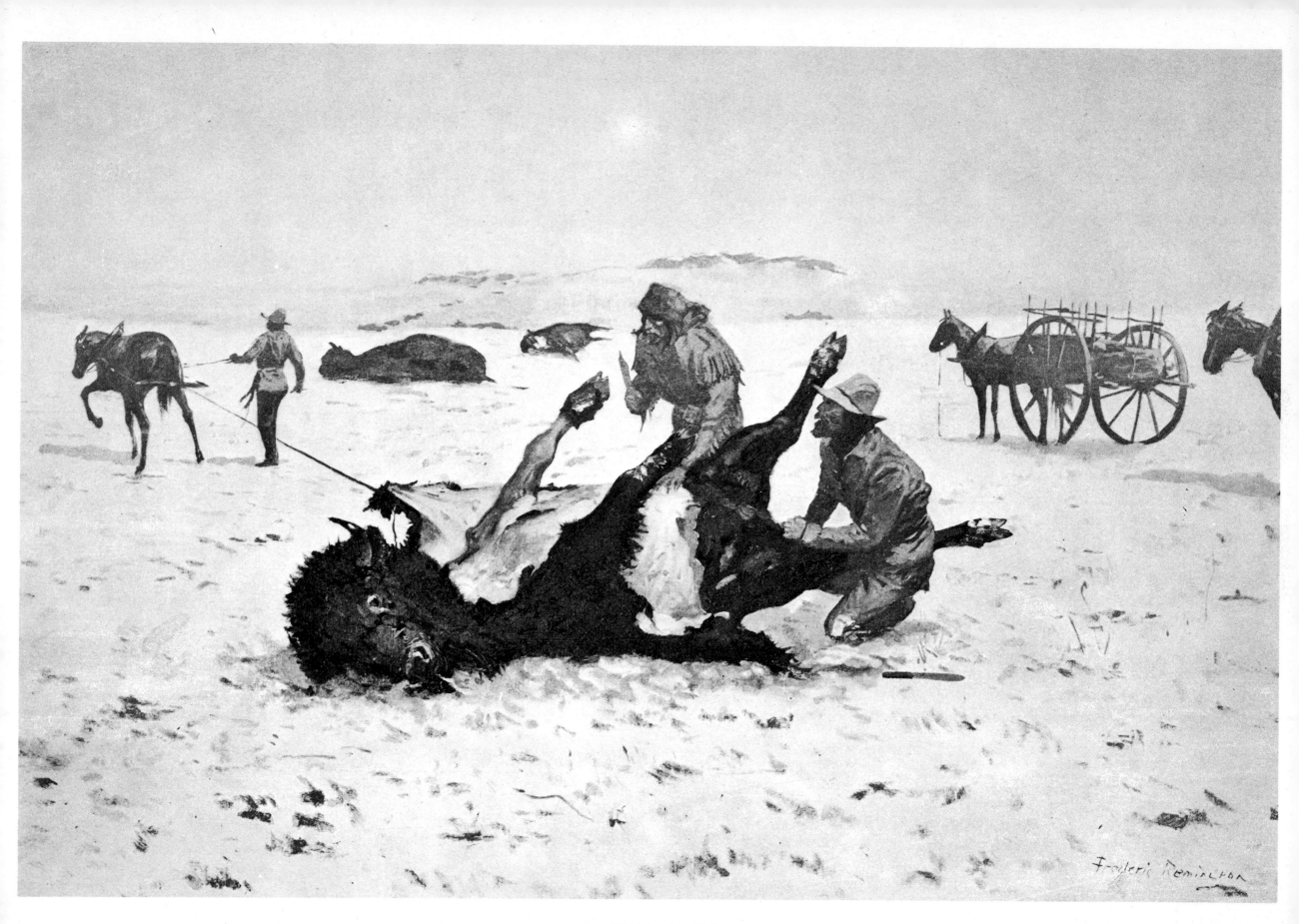

Taking the Robe.

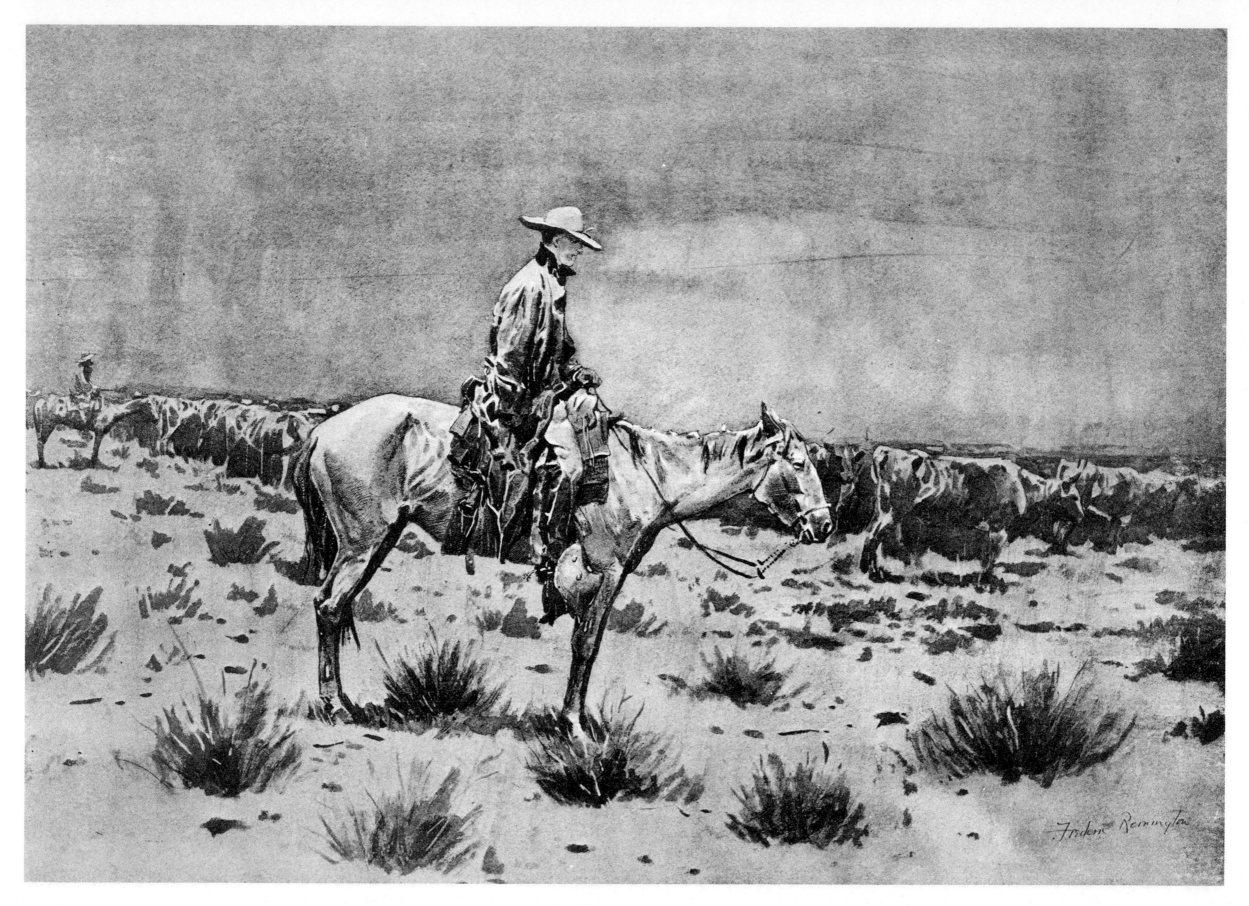

Riding Herd in the Rain.

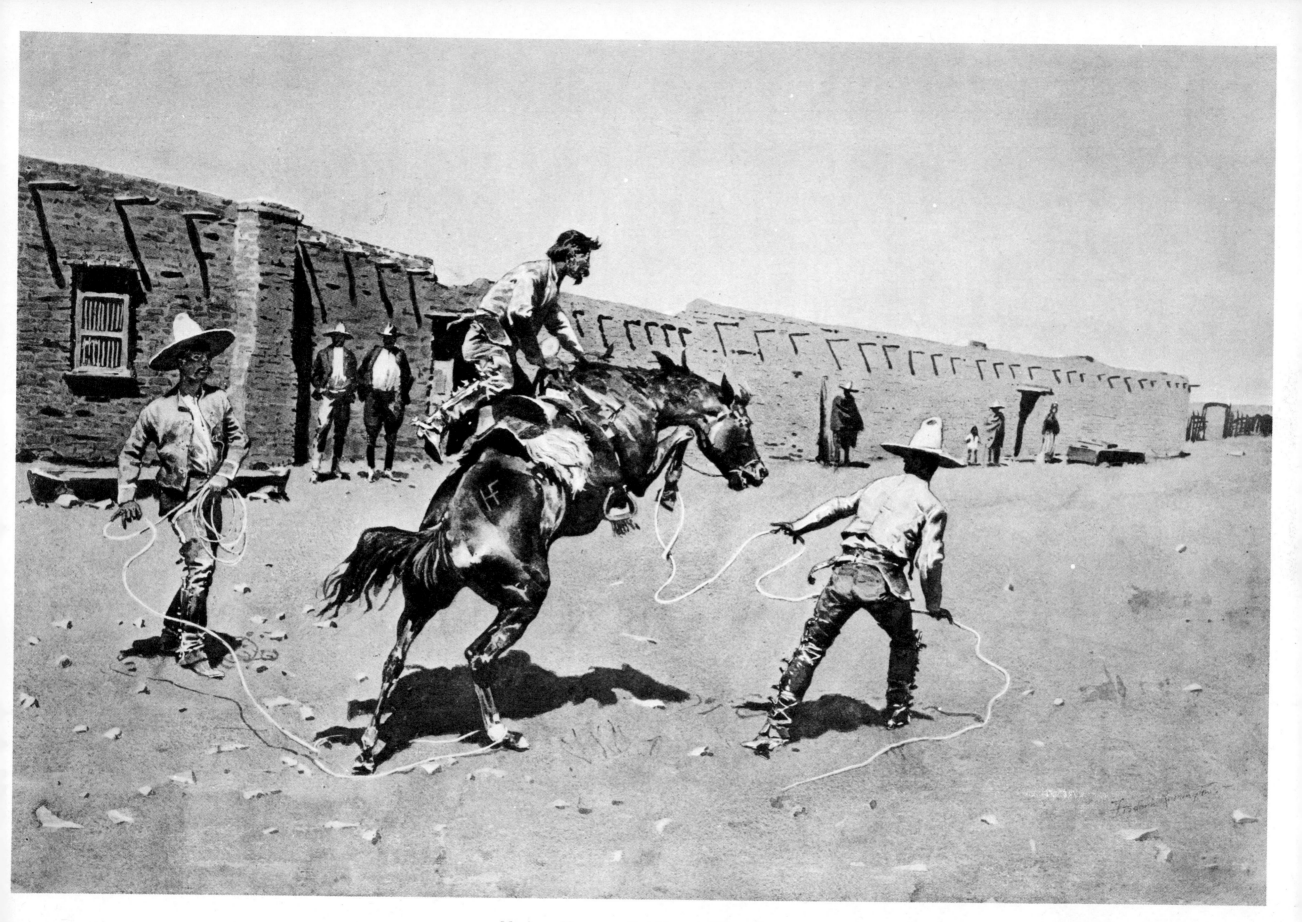

Mexican Vaqueros Breaking a "Bronc."

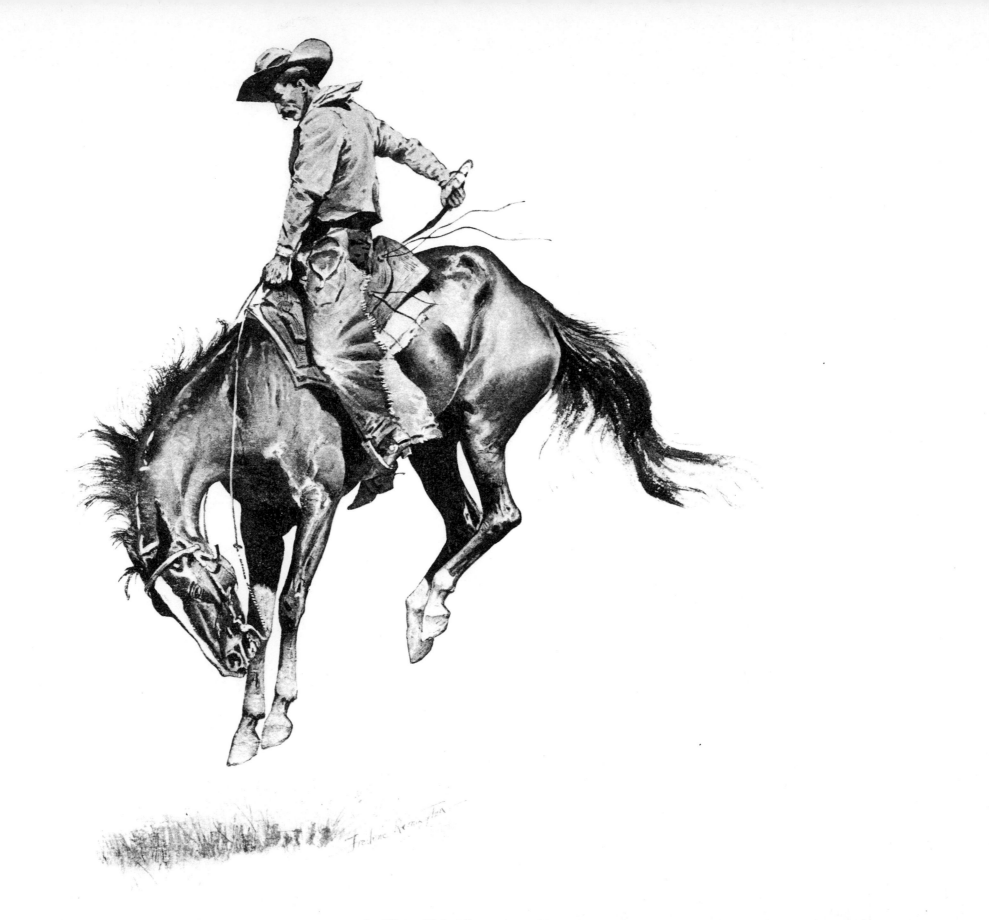

A "Sun Fisher."

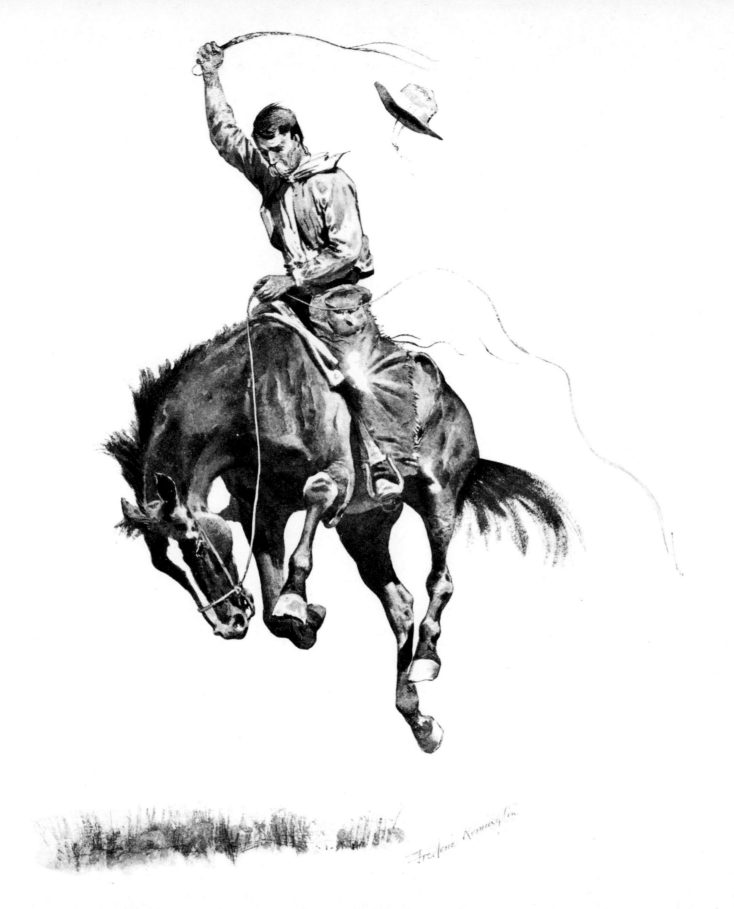

A Running Bucker.

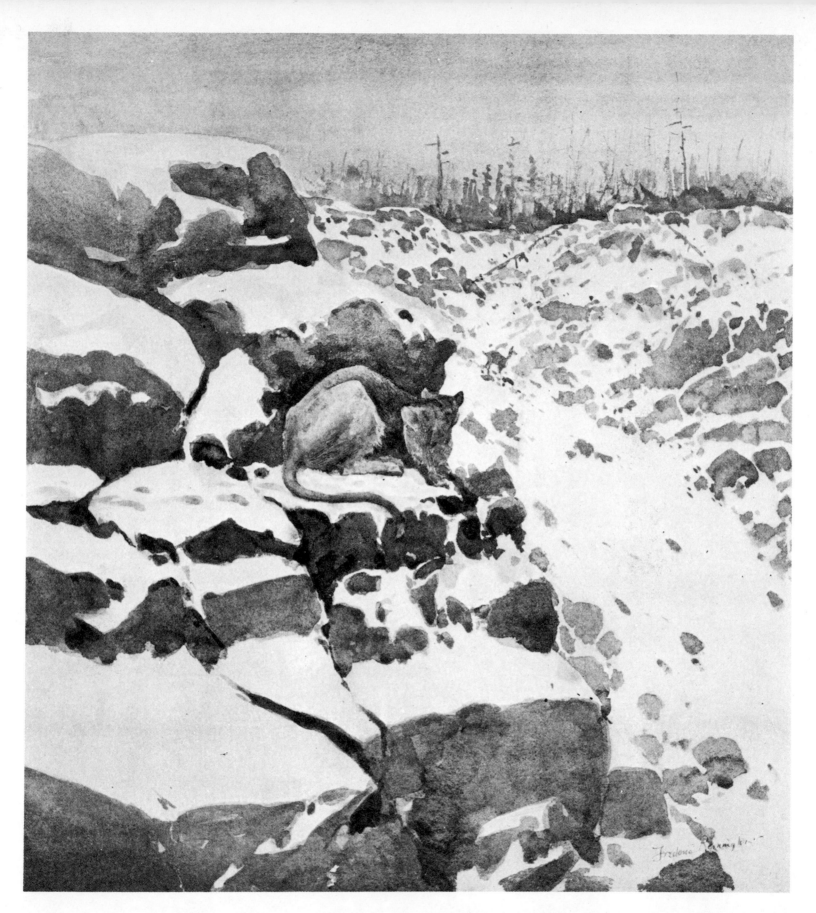

A Mountain Lion Hunting.

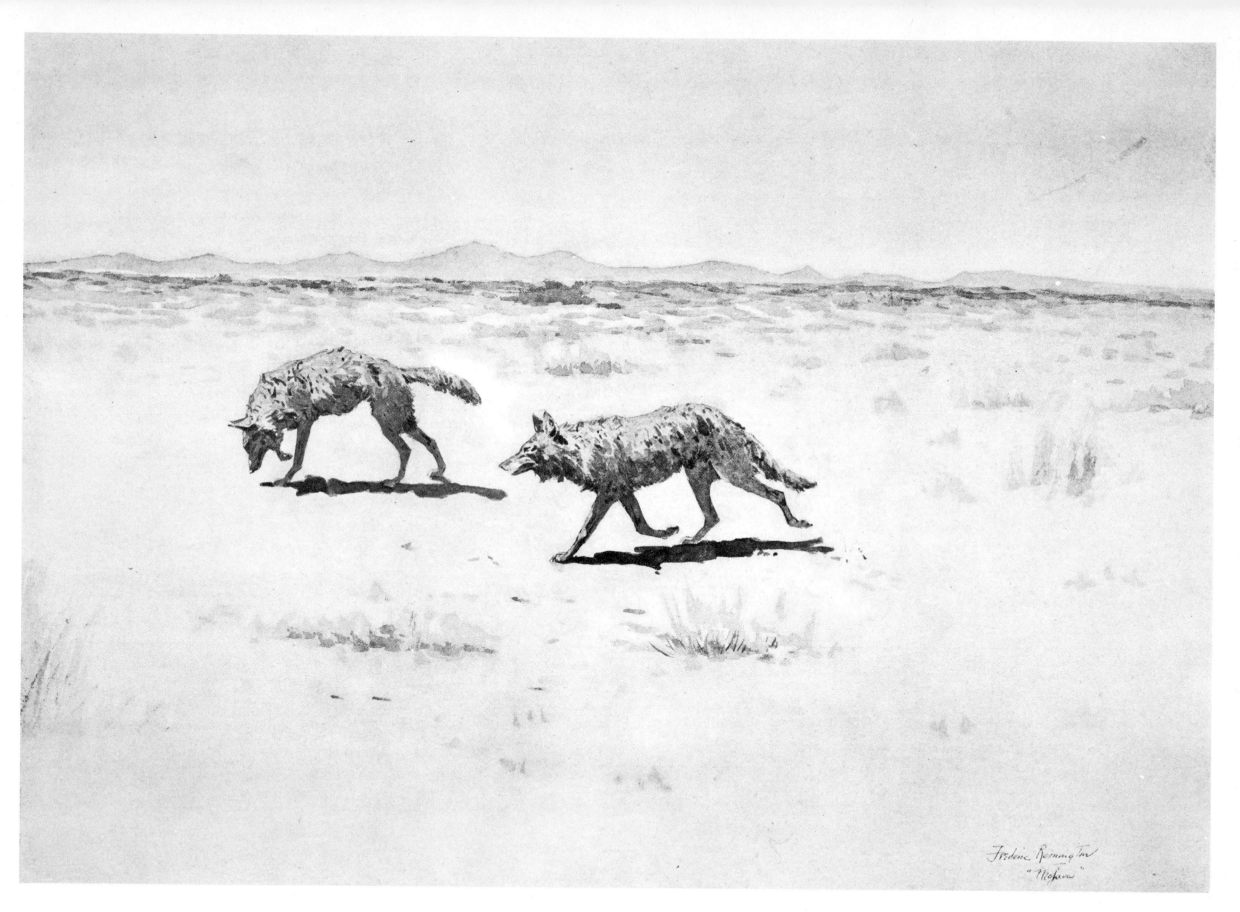

Coyotes.

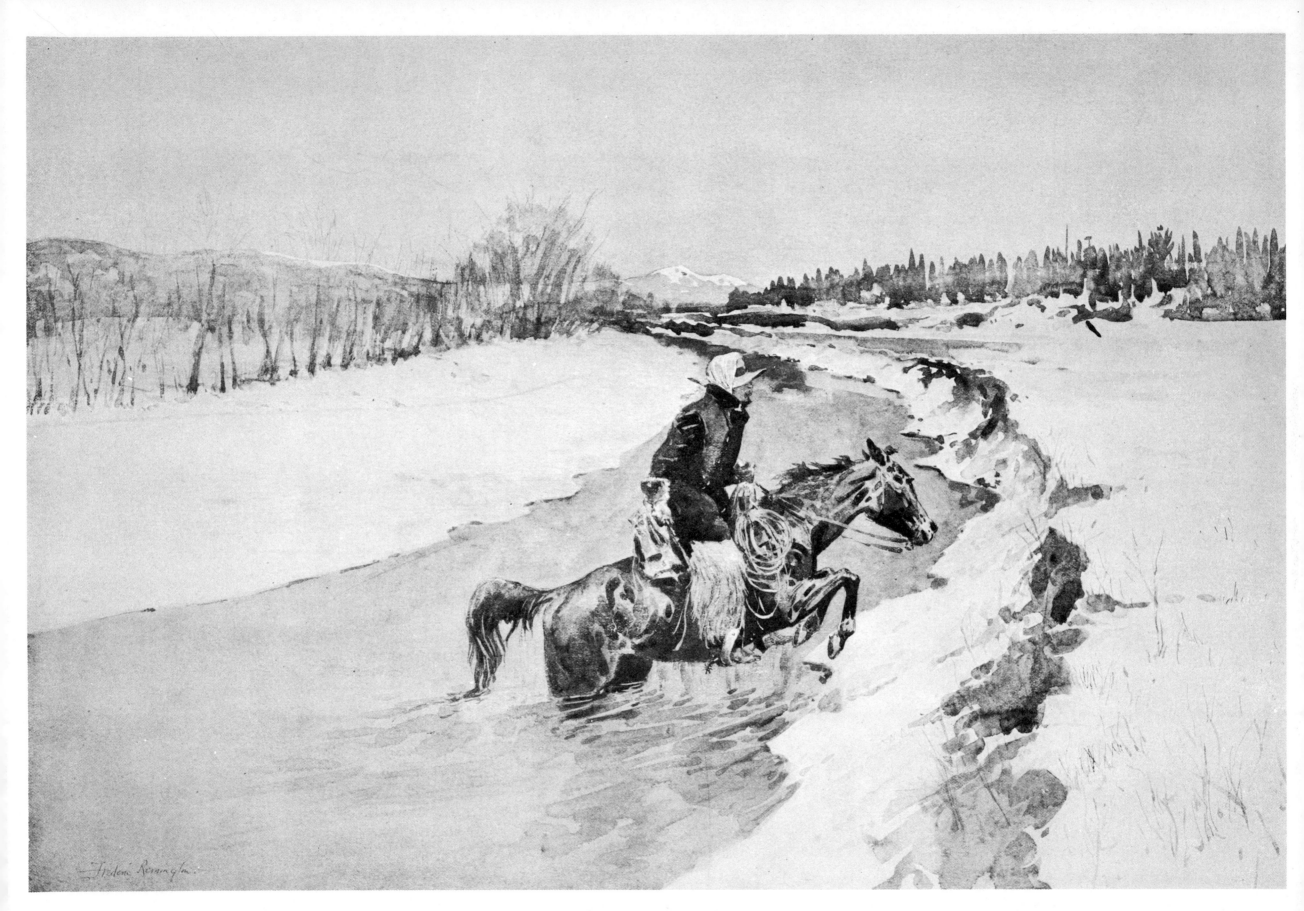

Riding the Range—Winter.

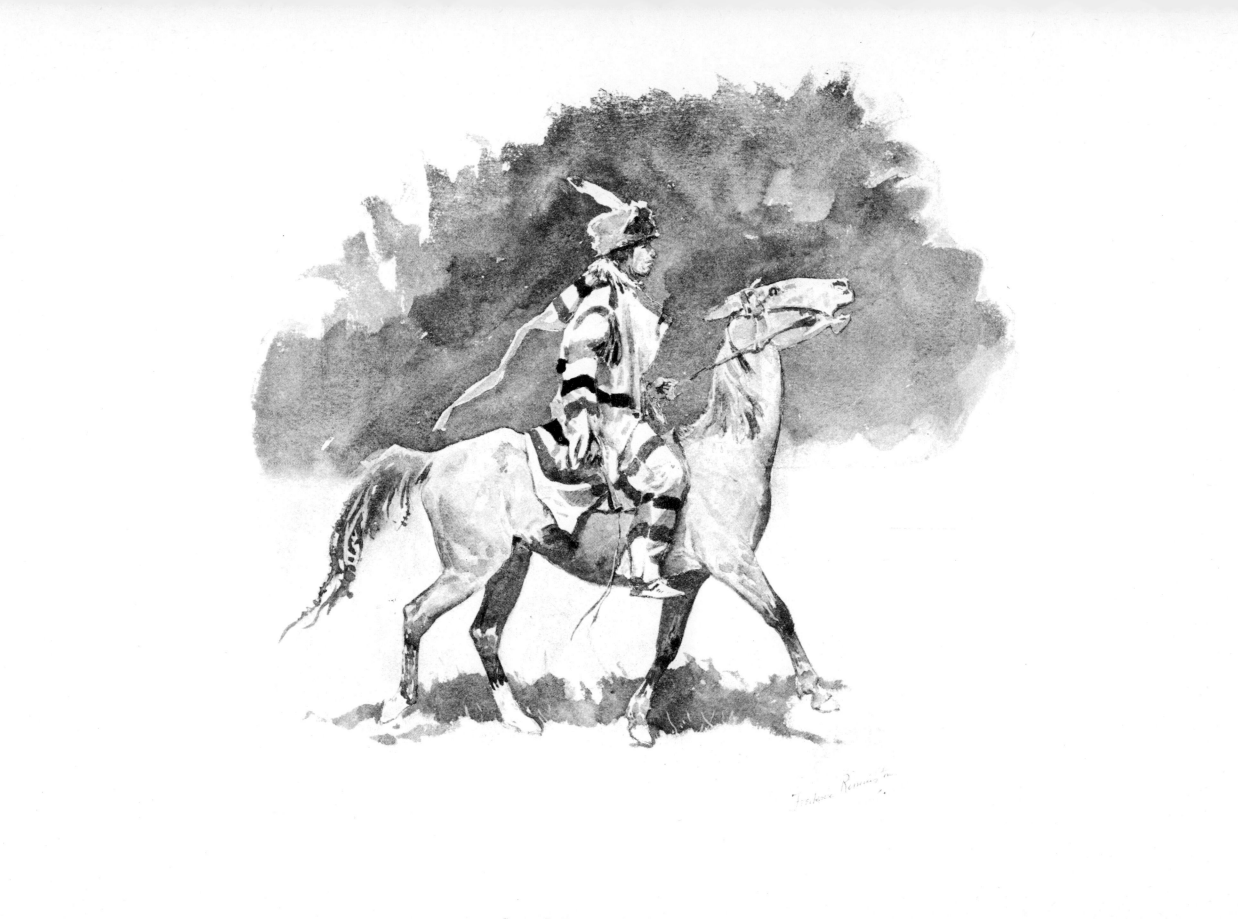

Snow Indian, or the Northwest Type.

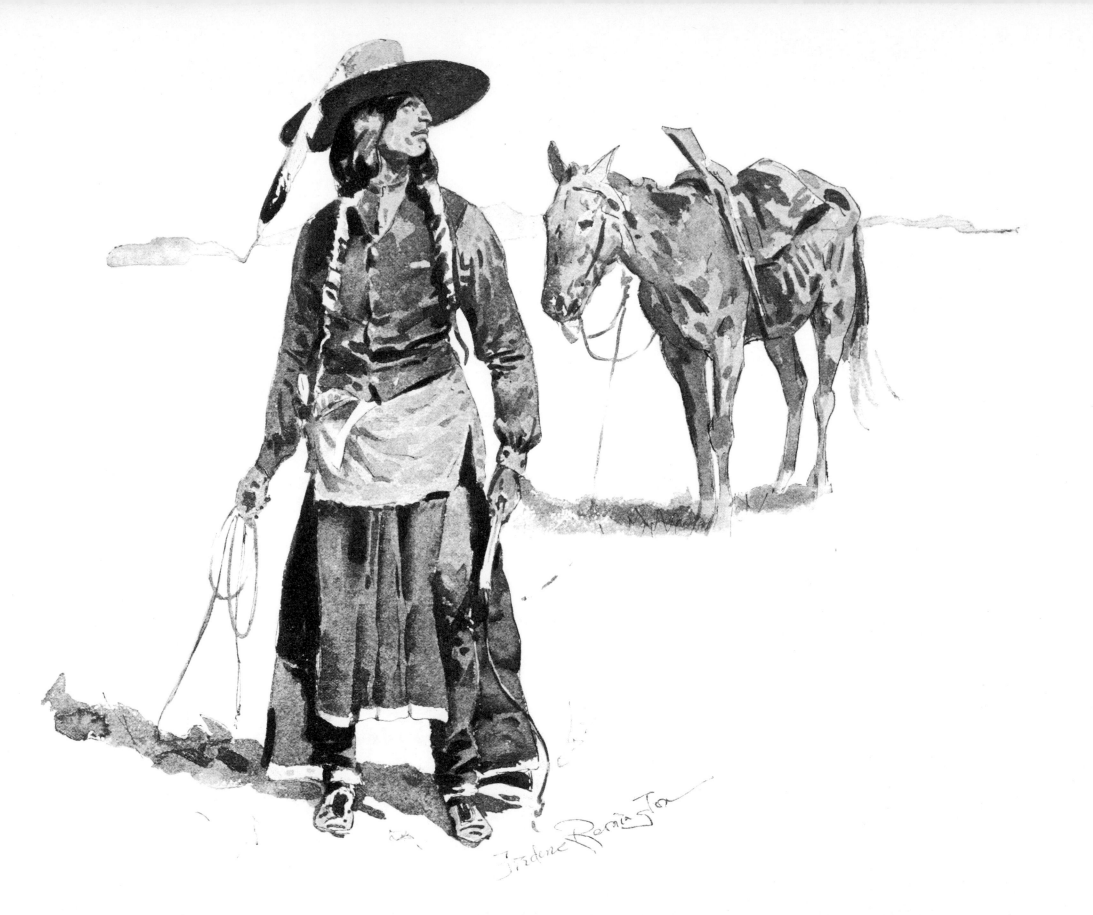

Nez Percé Indian.

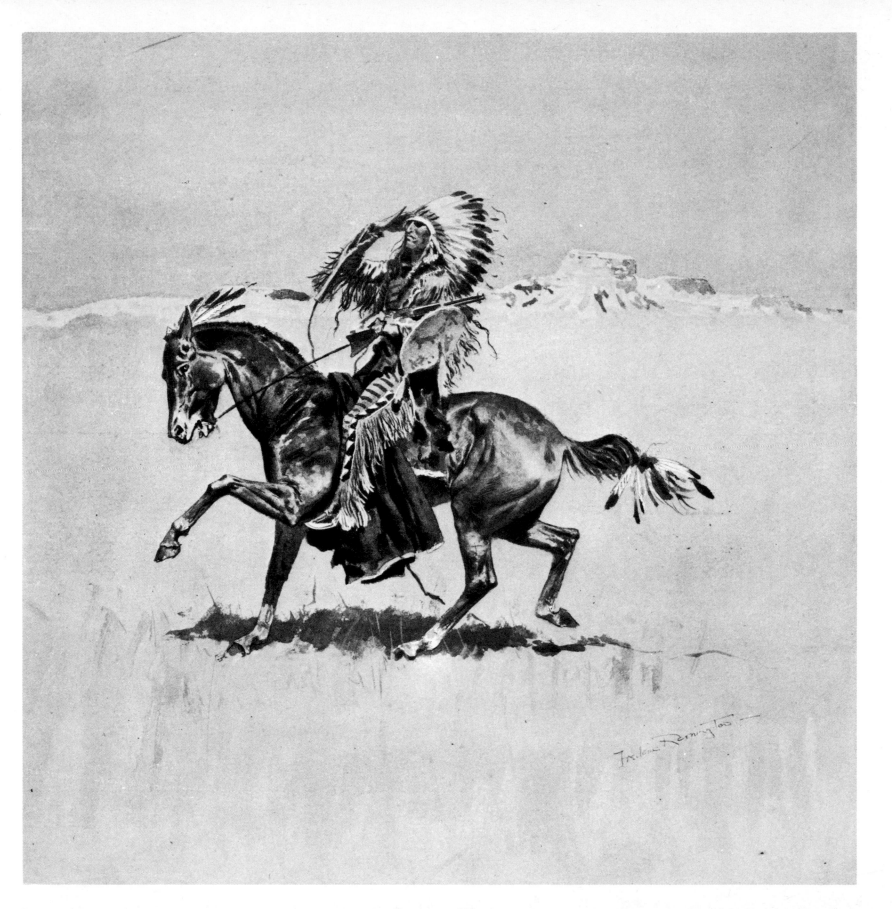

A Cheyenne Warrior.

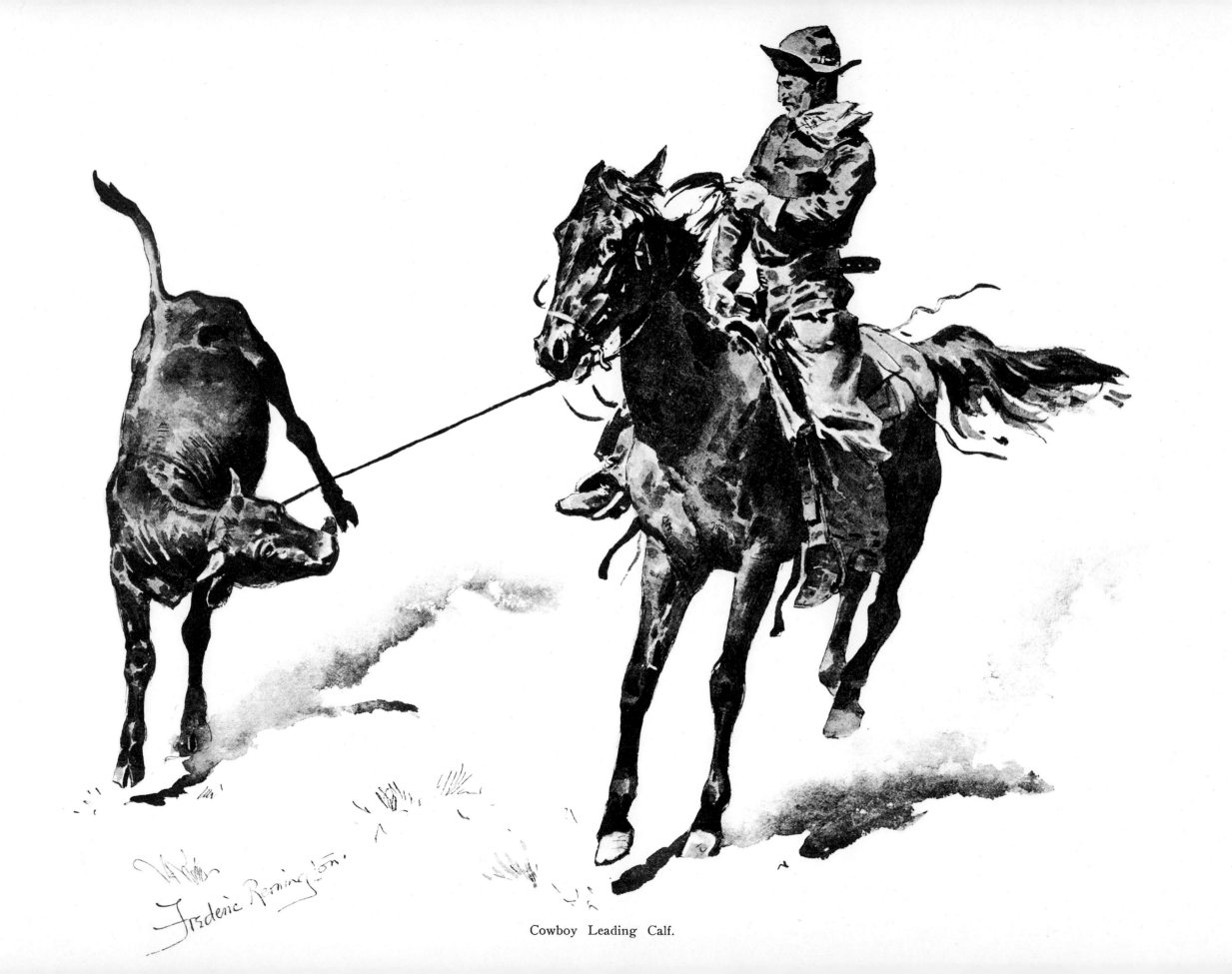

Cowboy Leading Calf.

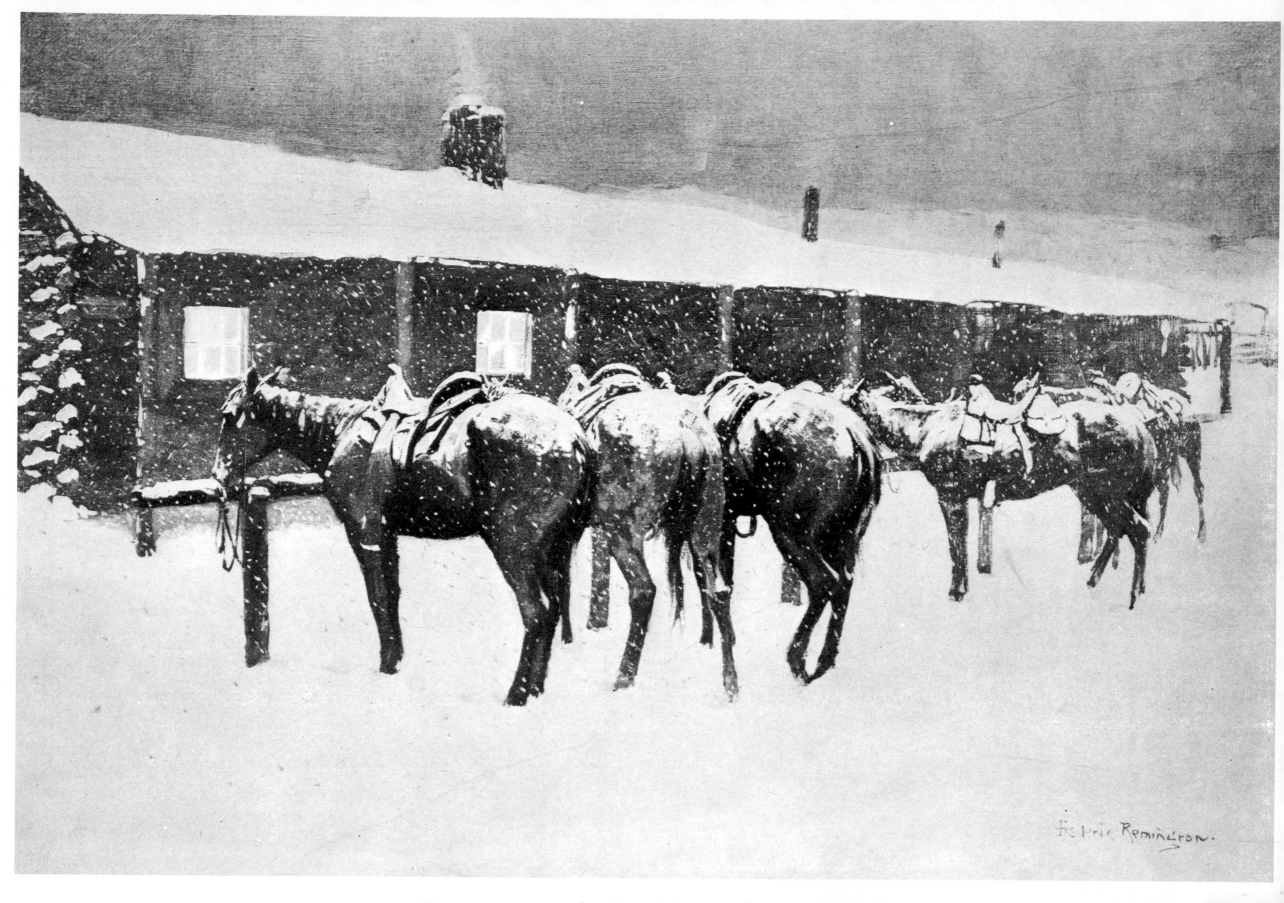

Cow Pony Pathos.

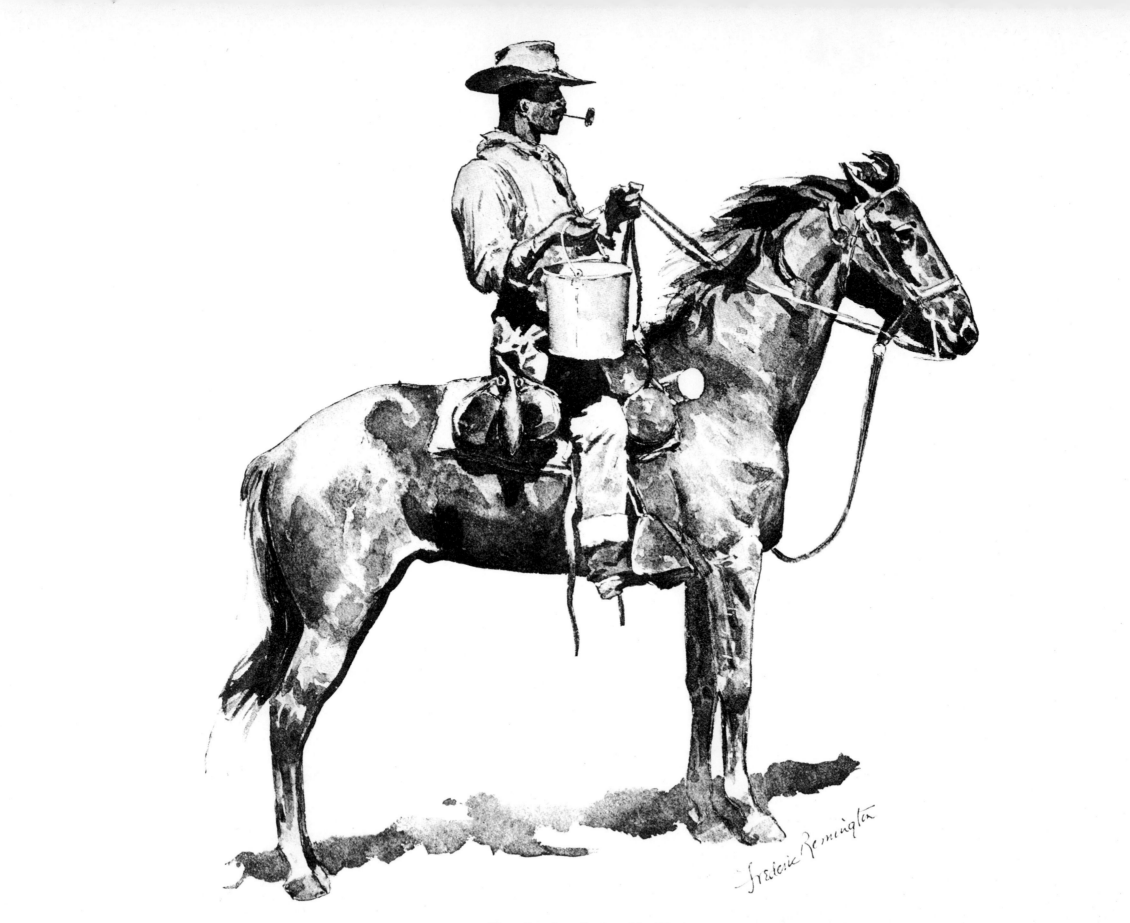

The Cavalry Cook with Water.

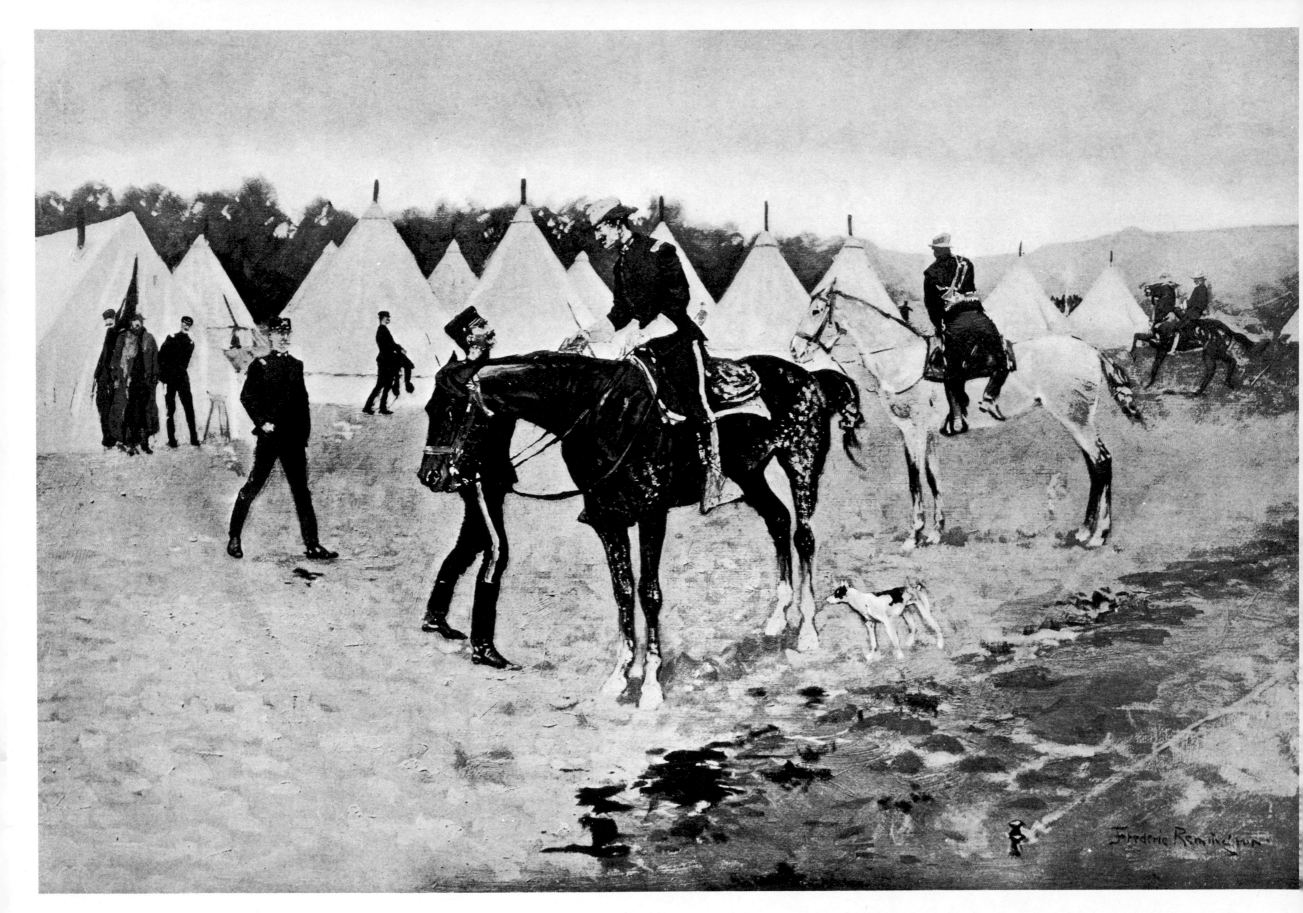

A Modern Cavalry Camp.

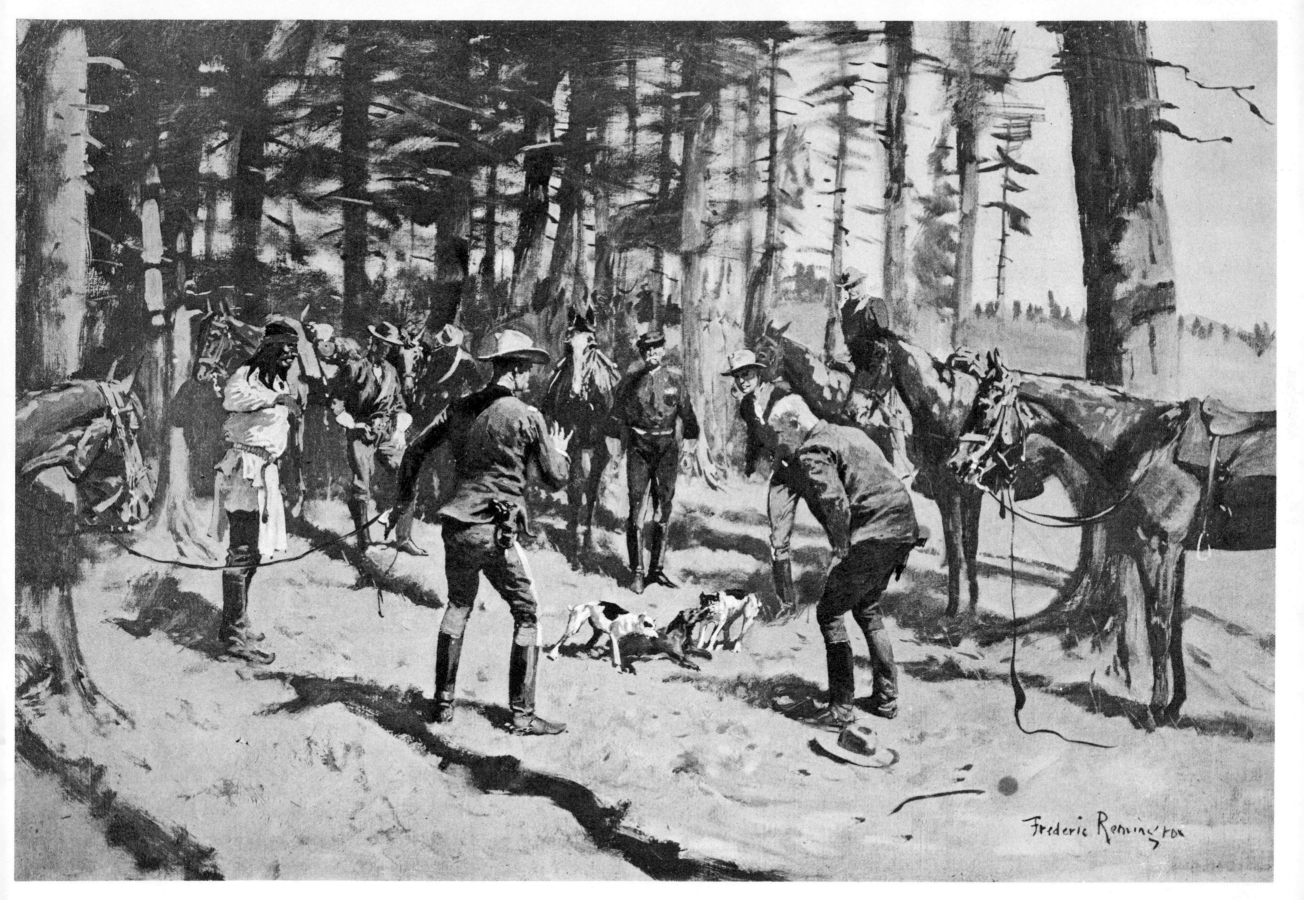

Fox Terriers Fighting a Badger.

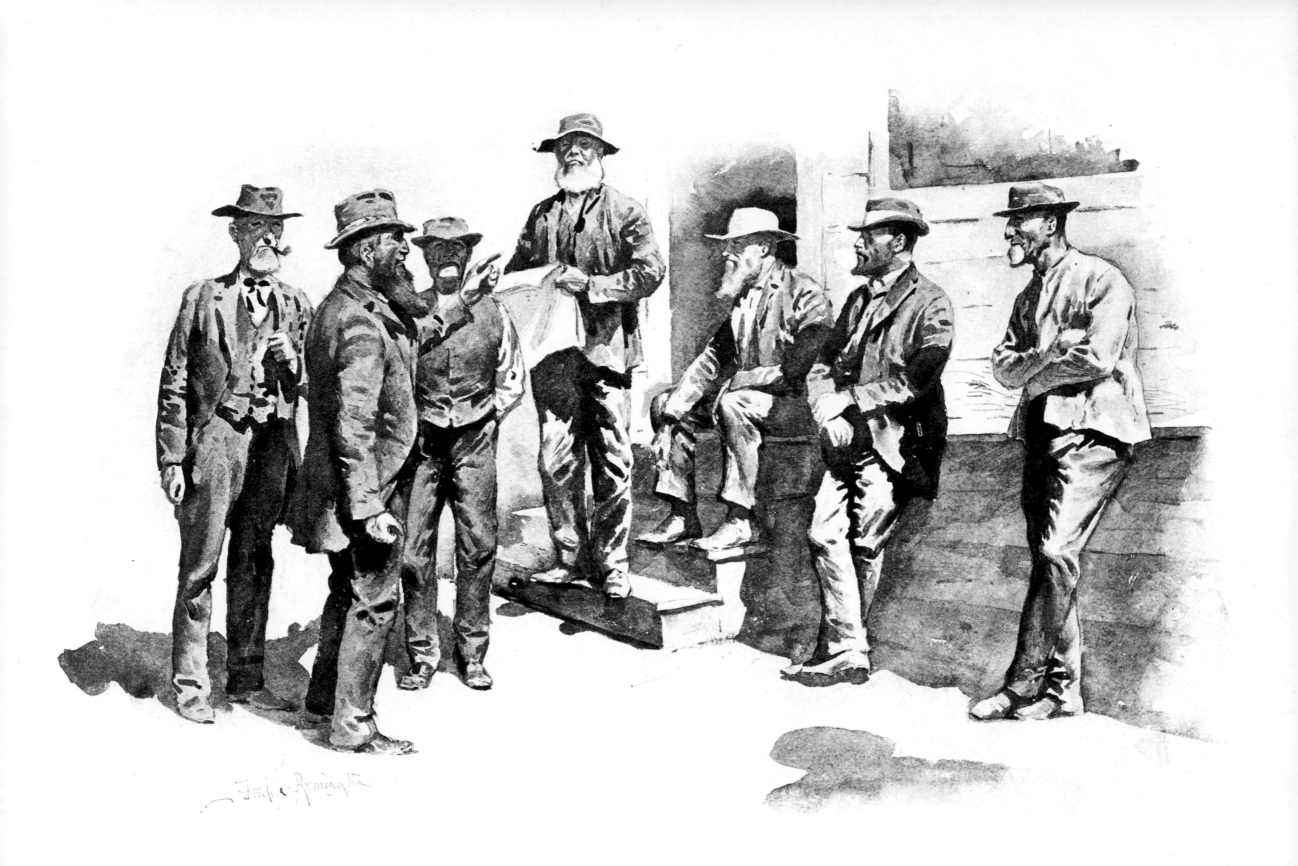

High Finance at the Cross-Roads.

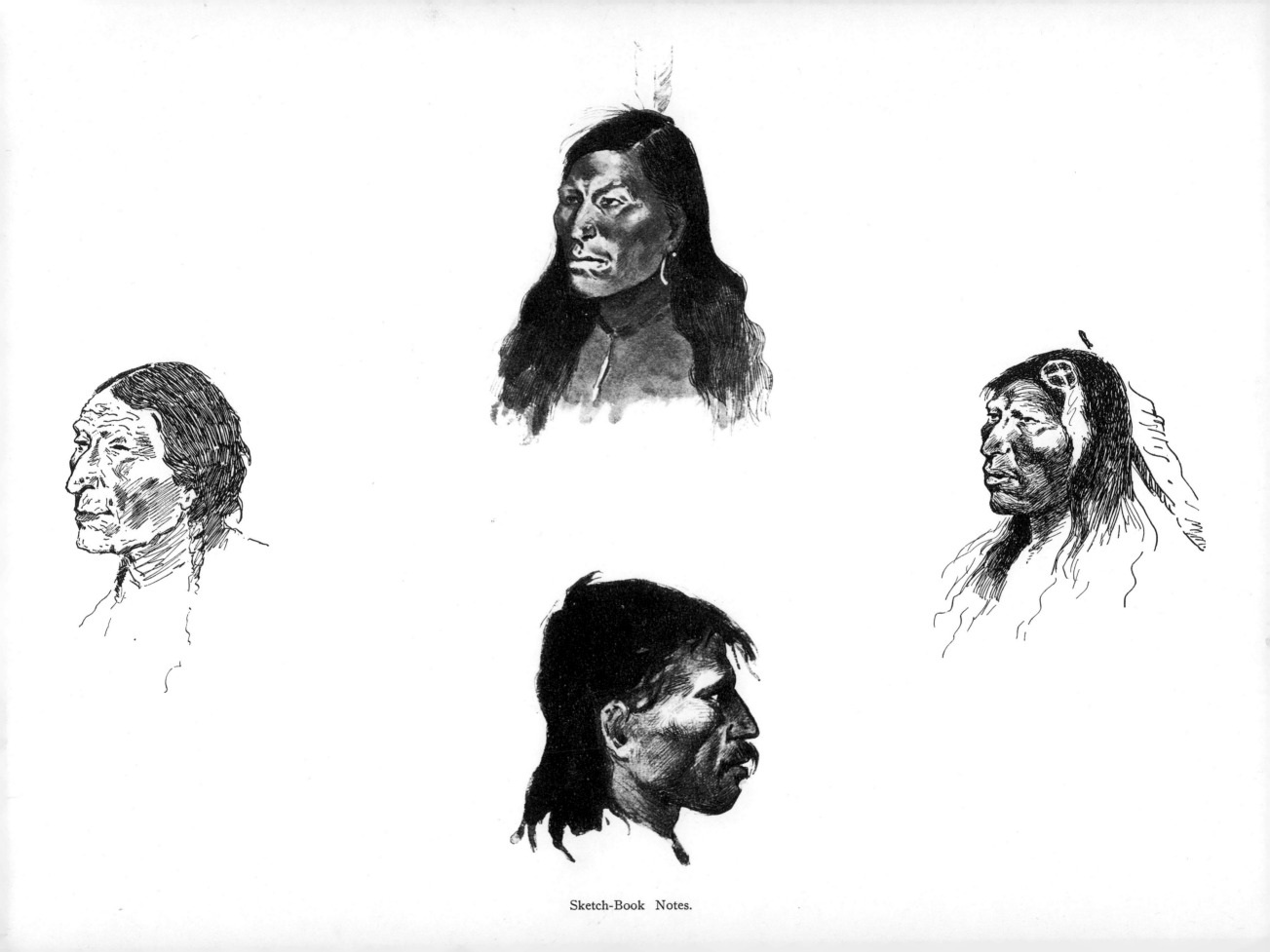

Sketch-Book Notes.

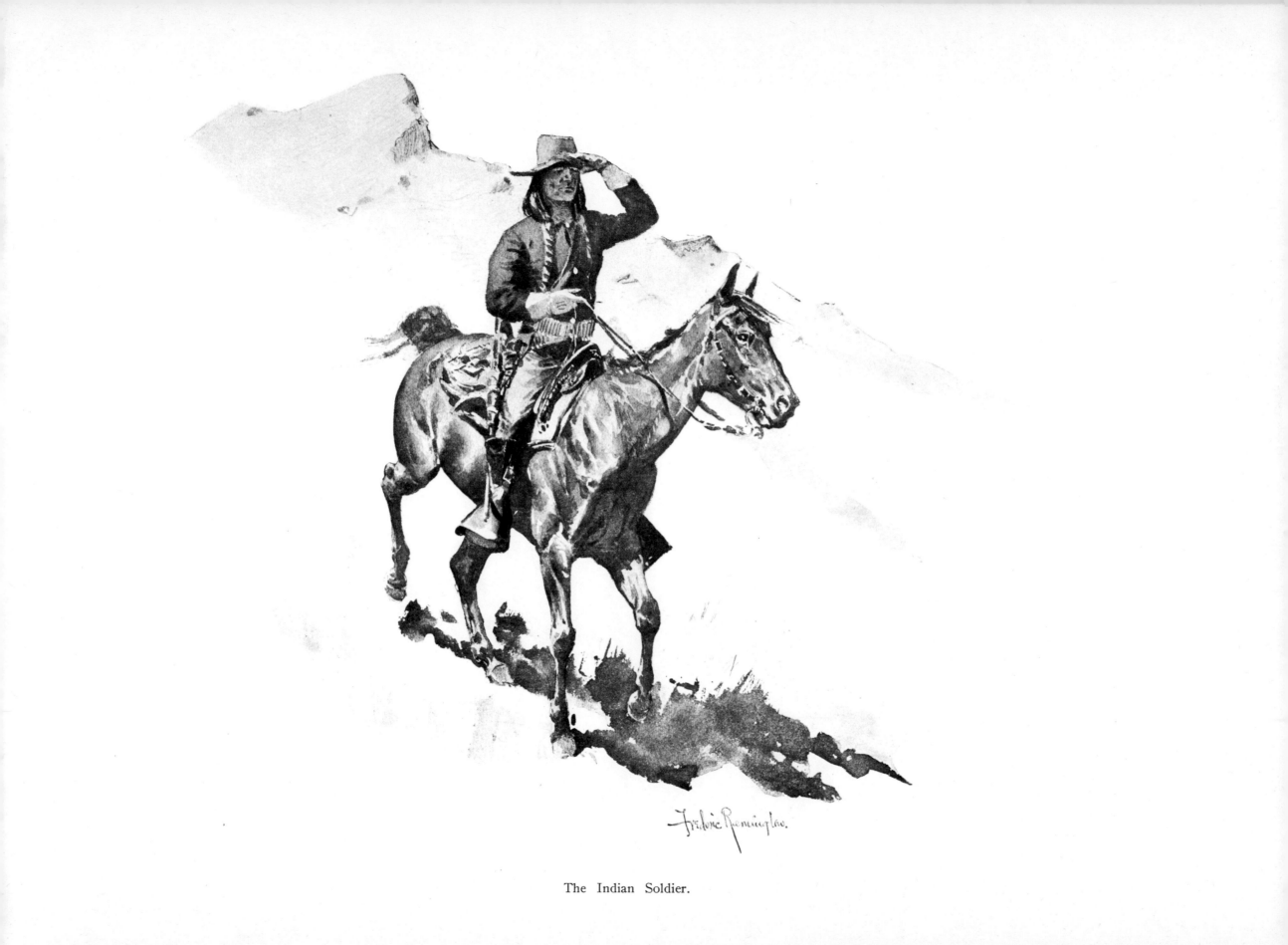

The Indian Soldier.

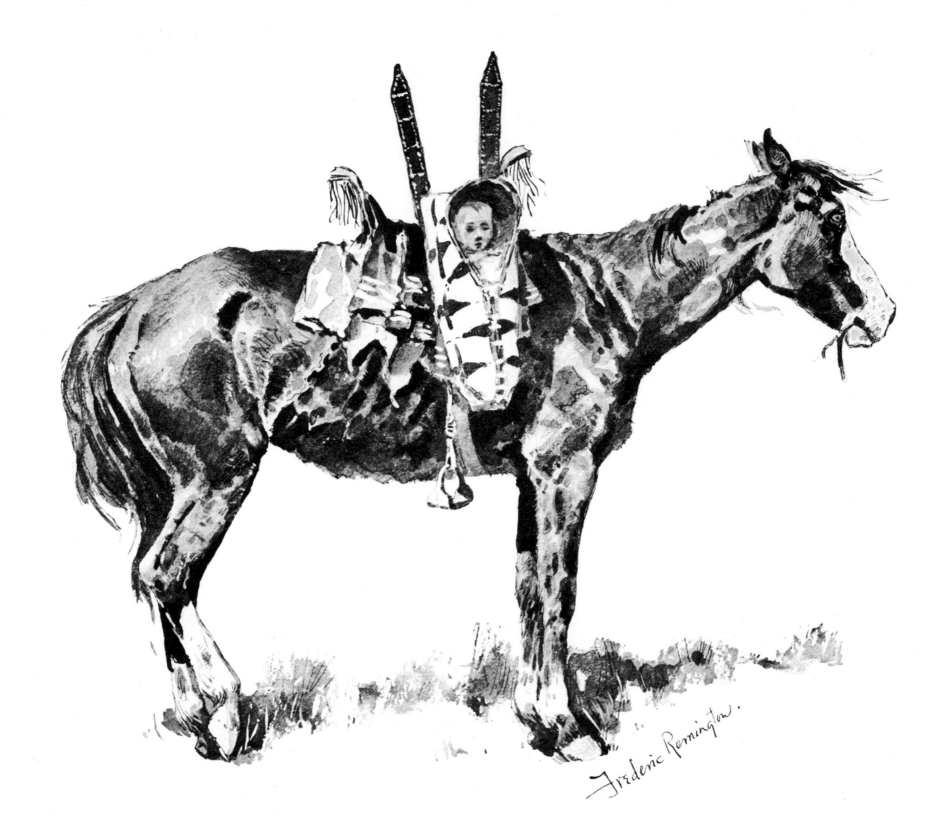

The Squaw Pony.

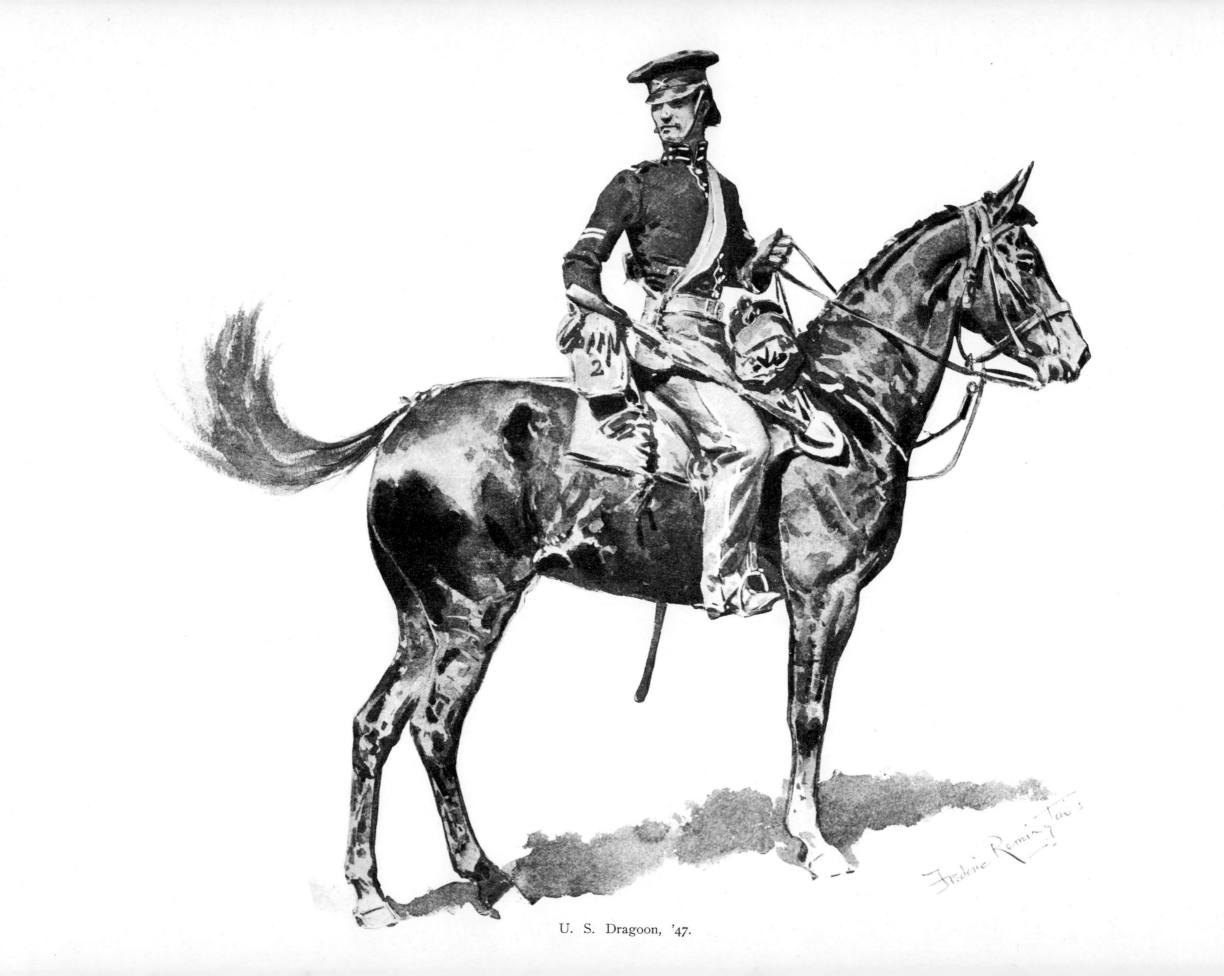

U. S. Dragoon, '47.

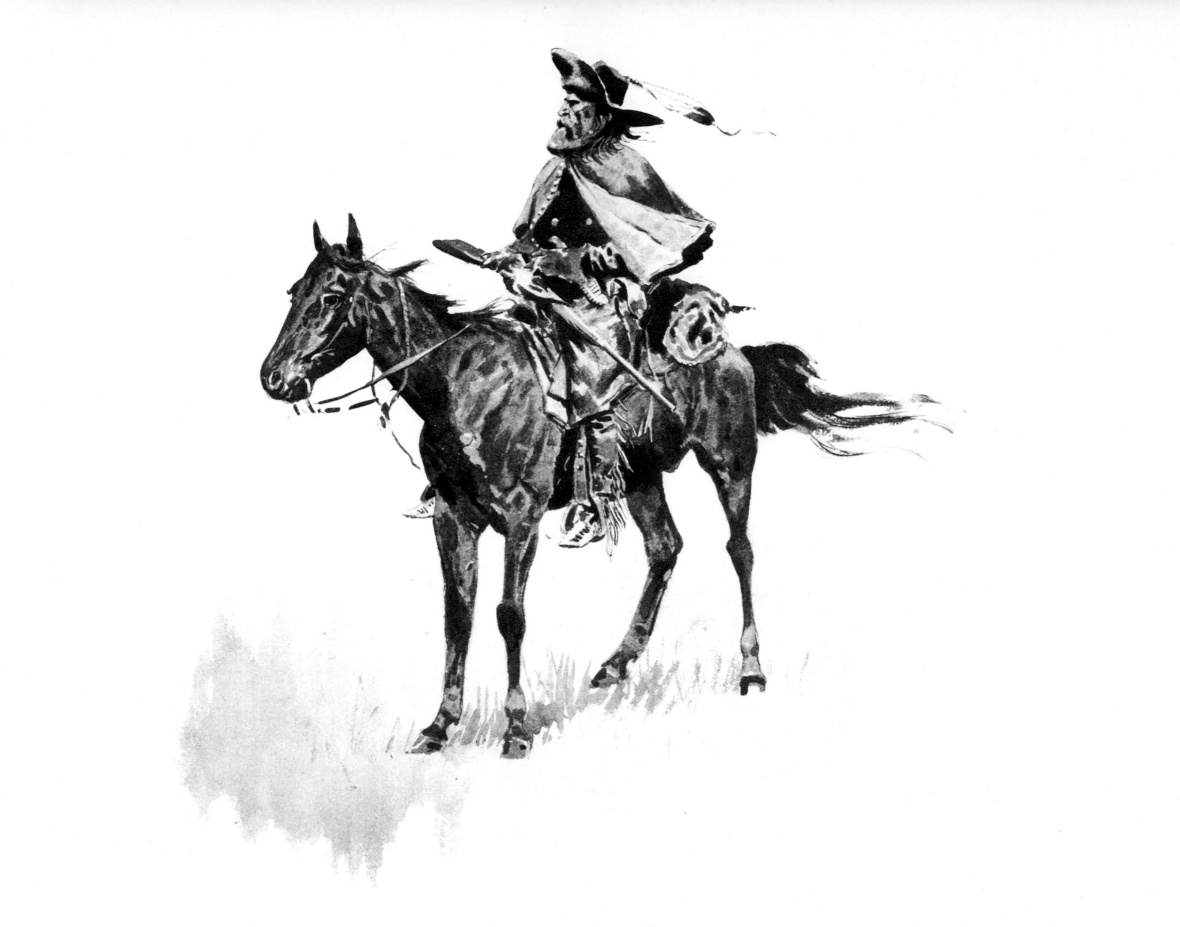

A Scout, 1868.

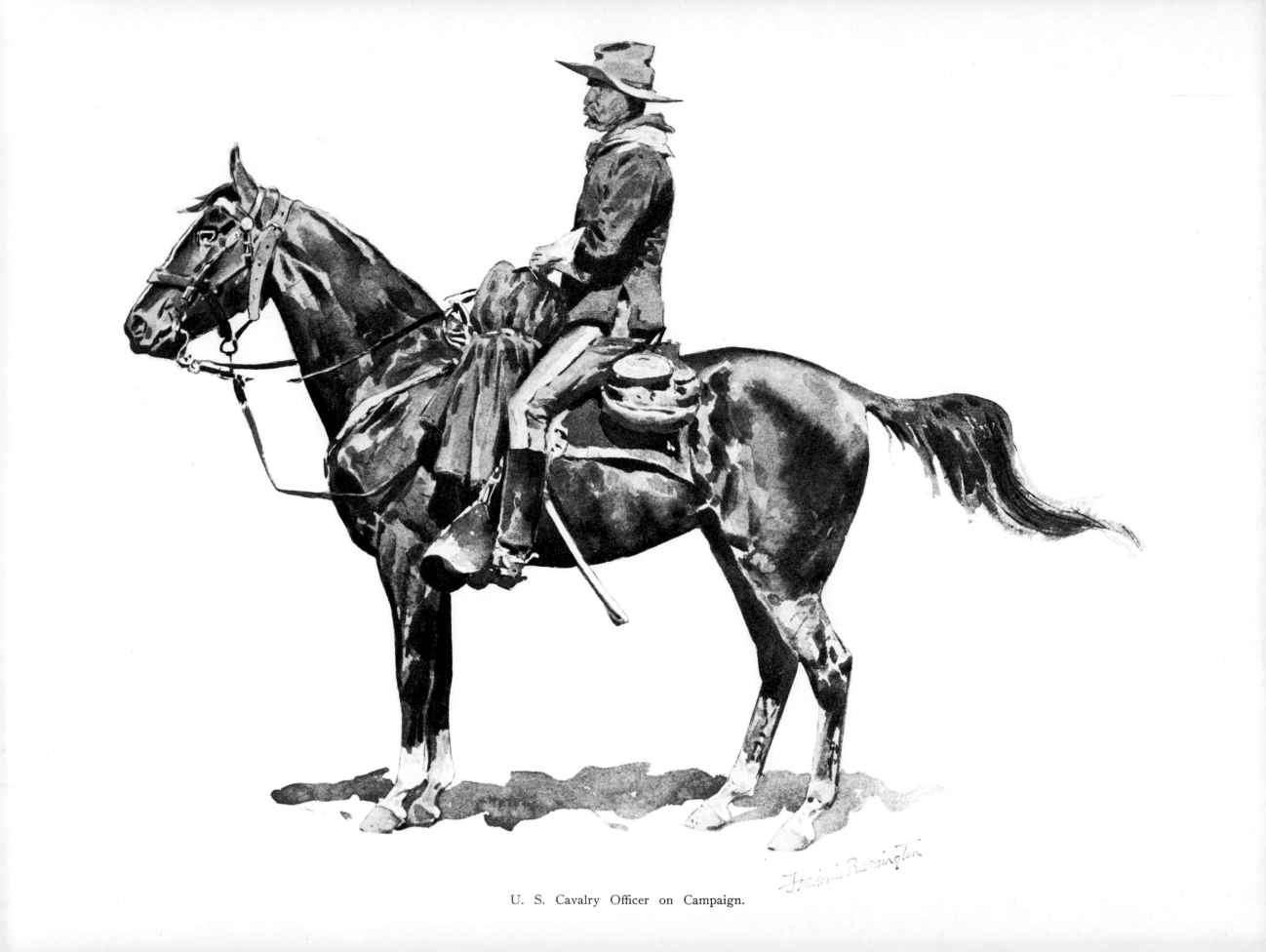

U. S. Cavalry Officer on Campaign.

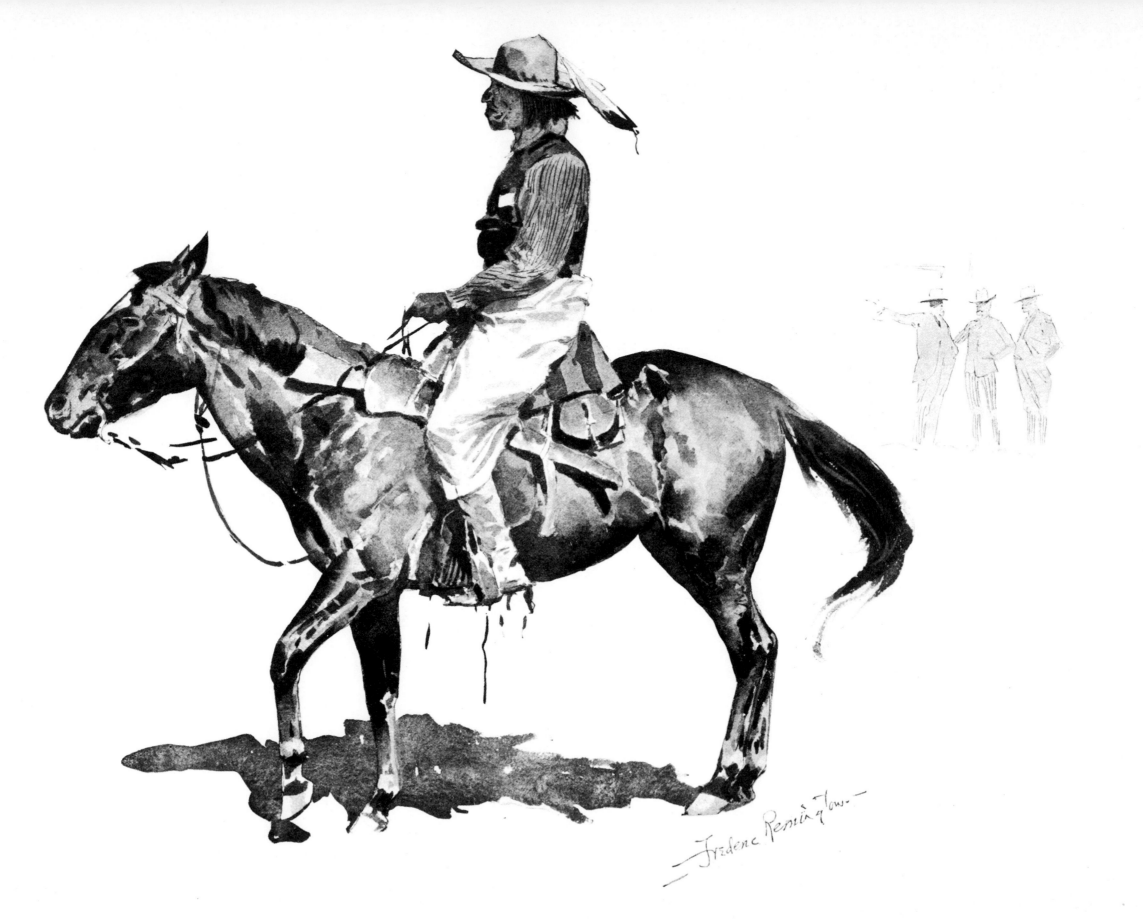

A Reservation Indian.

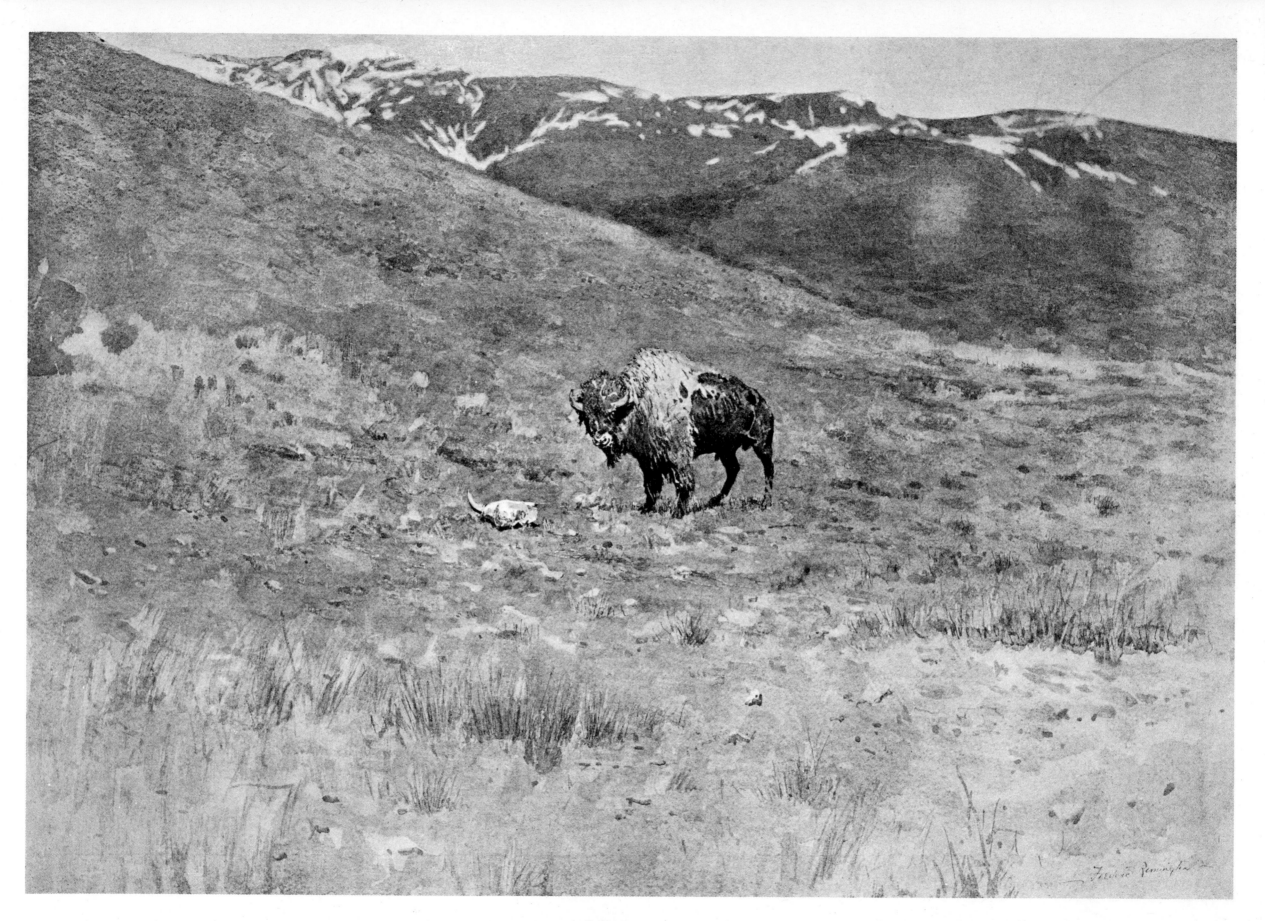

Solitude.

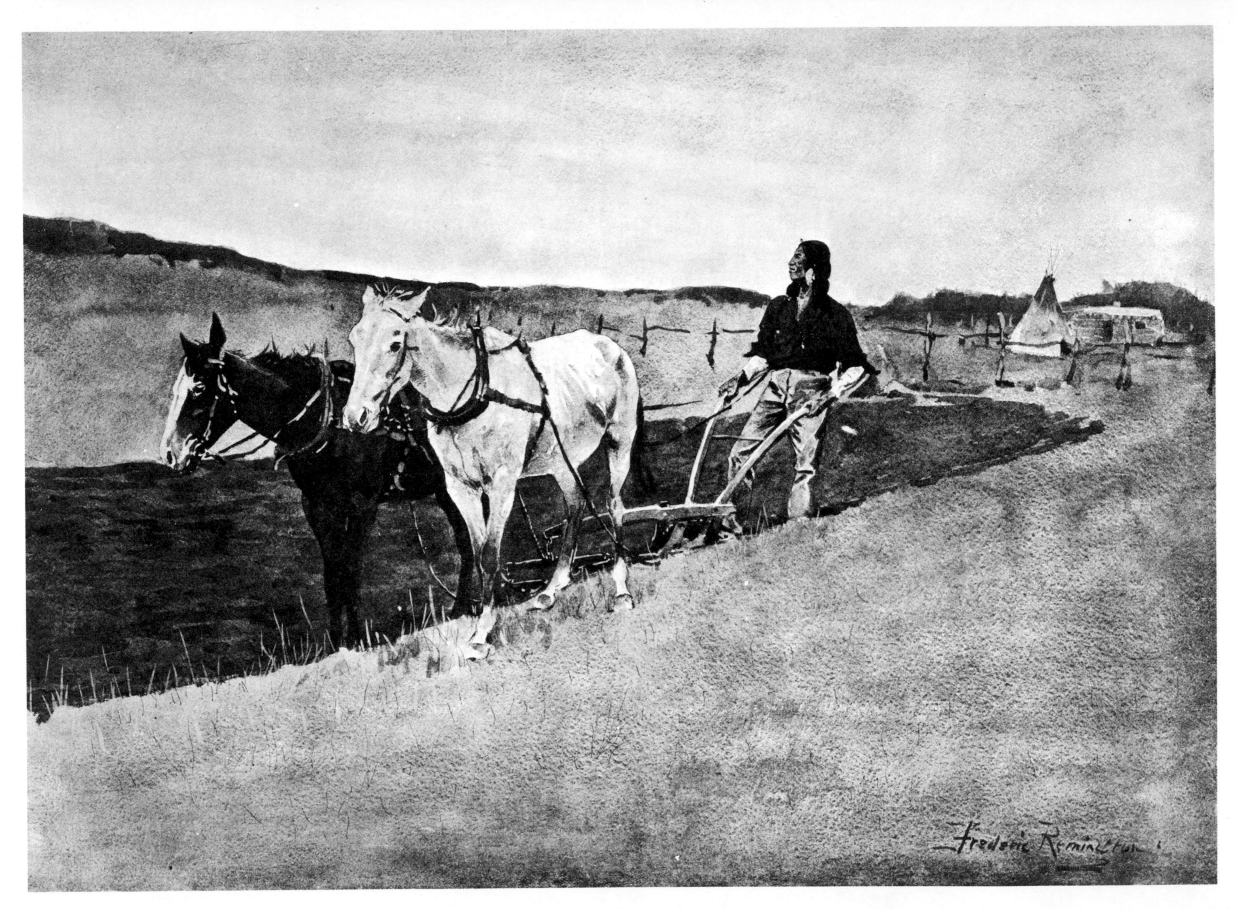

The Twilight of the Indian.